NEW DESIGN:
LOS ANGELES

ROCKPORT

series editor: **Edward M. Gomez**

associate editor: **Allison Goodman**

NEW DESIGN:
LOS ANGELES

THE EDGE OF GRAPHIC DESIGN

GLOUCESTER MASSACHUSETTS

ROCKPORT PUBLISHERS

FIRST PUBLISHED IN THE UNITED
STATES OF AMERICA BY:
Rockport Publishers, Inc.
33 Commercial Street
Gloucester, Massachusetts 01930-5089
Telephone: (978) 282-9590
Facsimile: (978) 283-2742
www.rockpub.com

ISBN 1-56496-757-3
10 9 8 7 6 5 4 3 2

Printed in China.

Designer: Stoltze Design
Cover Image: Photodisc

Acknowledgments

I am very grateful to my Los Angeles-based associate editor and collaborator, Allison Goodman, a graphic designer and teacher at the Art Center College of Design in Pasadena whose own work has focused on language and visual communication, and whose insightful background research and reporting have vitally enriched and helped shape the contents of this book.

I also thank my literary agent, Lew Grimes, for his energy and vision, and, at Rockport Publishers, editors Alexandra Bahl and Shawna Mullen, and art director Lynne Havighurst, for their keen attention and important contributions to the assembling of this volume and the development of the entire *New Design* series.

Most of all, on behalf of everyone involved in the production of *New Design: Los Angeles*, I thank the many cooperative, thoughtful and enthusiastic graphic designers who have kindly shared their work and their ideas with us, and who have allowed us to reproduce them in these pages.

—Edward M. Gomez

CONTENTS

In modern times, artists and creative types of all stripes have ventured westward to California, lured by its twin promises of beauty and bounty. Like the pioneering technician-entrepreneurs who founded Hollywood's legendary movie studios, many went for the light—and stayed, as much for the natural wonders as for the rewards of a new, young, less restrictive society. To this day, graphic designers, many with strong links to the now vast entertainment industries, continue to enjoy and find inspiration in an open, energetic, increasingly international environment that is aware of its uniqueness and resources. It is an independent-minded state that looks as easily to East Asia and the Pacific as it does to Mexico and Latin America. In Los Angeles in particular, California is a place of constant movement—of people, cultures, products, styles, and trends; it is a city in constant motion where many find an emblem in and on the road.

Since the mid-1980s, Los Angeles graphic designers have also had to learn to "drive" another ubiquitous, indispensable machine. It is one that has become as much a symbol of their state as the automobile, as well as the most important tool of their profession. It is the desktop computer, and Los Angeles designers have taken to it with enthusiasm and verve, often as innovators in their use of its capacities for typography, image-handling, and other fundamental aspects of the art and science of visual communications.

Southern California Institute of Architecture Poster
CREATIVE DIRECTORS: Sean Adams,
Noreen Morioka
PHOTOGRAPHY: Anthony Terumi

LuxCore Web site
DESIGNER: April Greiman
COMPUTER PUSH ANIMATION: April
Greiman, Neal Izumi

Designer April Greiman was one of the first to embrace the Apple Macintosh computer, which was introduced in 1984, and to envision its broad potential for the communications-design field. Her experiments with collage-like layouts for posters and her use of multiple typefaces within the same headline or logo, often not in adherence to any underlying modernist, rectilinear, organizing grid, anticipated the techniques and looks that today's relatively easy-to-use hardware and software would soon allow and engender. Greiman coined the term *hybrid imagery* to refer to the blending of traditional (now old-fashioned) photomechanical techniques of print production with the new digital technology's abilities to manipulate texts and images and to compose whole pages and books on a screen.

In a business and cultural environment strongly influenced by and sensitive to technology and media—after all, southern California is a center of the entertainment, aerospace, and advertising industries—graphic designers have taken to the computer partly out of an eagerness to explore its reach and partly out of necessity.

It's no secret that the computer has become the most powerful resource in graphic design and other communications fields. At the same time, with the telecommunications explosion that has brought the world to any Internet user or TV viewer's fingertips and screen, computers have begun to redefine the

purposes and aesthetic principles that for generations have guided and shaped graphic design. The computer's radical effects on visual literacy and on language itself have reinforced such critical points of view even as they have given expression to new forms of communication—hypertext, motion graphics—hitherto inconceivable on the printed page.

Thus, many Los Angeles designers speak with excitement about, and have rushed to explore, the new avenues of cross-disciplinary, cross-cultural discourse that rapidly evolving technologies have opened up, and the new techniques and opportunities for artistic expression that they have introduced. "The understanding of time-based design will now define and direct the professional landscape," observes designer Geoff Kaplan. He recognizes the inescapable role of the fourth dimension—time—in such new and proliferating formats as Web pages, motion graphics, and interactive applications of all kinds that incorporate information-carrying screens.

In the meantime, printed materials of every size and format already have reflected the daunting power of digital tools—and, arguably, have demonstrated many a designer's tendency to create in a certain manner because a software program has compelled him to do so. This can be seen in everything from the obligatory multi-layering of images and type that now appears in or on so many brochures, books, and packages, to the aggressively unconventional layouts created by the pop-culture magazine *Raygun*'s former but lastingly influential art director David Carson. Such work has been revered by postmodernist aesthetes who have relished its way of giving concrete expression, in a deconstructionist mode, to the otherwise merely conceptual, unexpected, formula-busting possibilities of

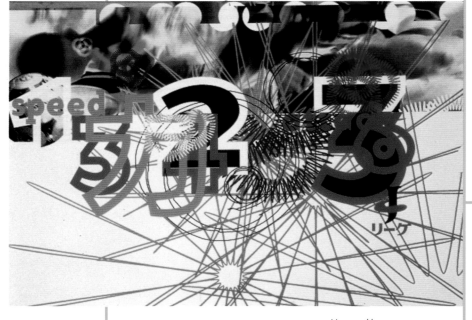

J League video sequence
DESIGNERS: Geoff Kaplan, Kyle Cooper

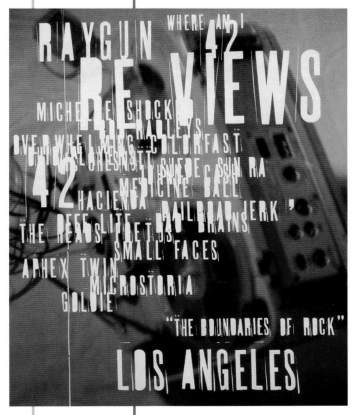

what a printed page can be. It has also been derided as chaotic and decadent, or self-indulgent and irresponsible, not to mention downright illegible.

"I basically feel like I'm painting with type and images," Carson has said of his efforts to visually convey the emotion of a text. His work has spawned a whole international school of—depending on a viewer's point of view—fashionably disagreeable or intelligently challenging graphic design that turns up regularly in pop-music, fashion, and other hip-design settings. Distilled for the masses, it also has made its way into television and the movies. Having quickly emerged as just another style in its own right, it is one more visual language, with its own grammar and

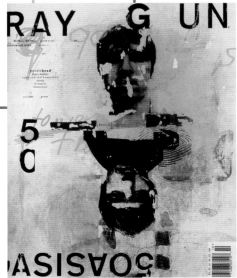

Raygun *covers*
ART DIRECTORS: Chris Ashworth and Scott Denton Cardew; Robert Hales

vocabulary, however erratic, that many Los Angeles designers, like their counterparts in other large media centers, have swiftly and capably assimilated.

"I try to keep up with what's happening in the world and to remain open—but not a slave—to new trends," notes designer Kim Baer, echoing a sentiment shared by many of her Los Angeles colleagues. "I read voraciously and try to do the best work I can without resorting to any grand formulas or panaceas about 'what will work.'" Baer recognizes that graphic design can and should be about clarity and organization on the one hand, and about style on the other. The first aspect is as much a reflection of a designer's talents and skills as the second is an expression of a very human need to feel forward movement and progress—to experience what Baer calls "a visual landscape that changes."

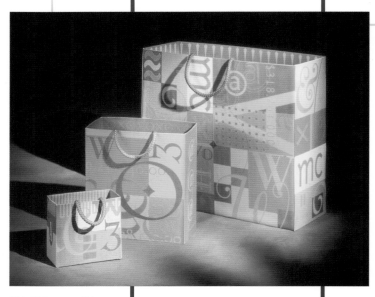

Michel & Company gift bags
DESIGNERS/ILLUSTRATOR: Maggie van Oppen

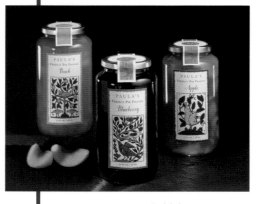

Jar labels
ART DIRECTOR: Kim Baer
DESIGNER: Maggie van Oppen
ILLUSTRATOR: Sudi McCollum

E! Entertainment Television promotional items
DESIGN: Vrontikis Design Office

So, too, are dramatic shifts apparent in the professional landscape in which Los Angeles graphic designers ply their trade. Thanks again to the influence of new technology and telecommunications, and to the past two decades' massive structural changes in the economy to which these same forces have contributed, some designers now regard large design firms as outmoded dinosaurs, whose vaunted "full-service" offerings, high overhead, and glitzy images are no longer cost-effective. Some argue that these larger companies have become too dependent on corporate clients with deep pockets (read: the entertainment industries) whose more or less similar, marketing-driven needs tend to produce generally uninteresting, homogenized design.

Alternatively, many notable small, one- to three-person design studios have sprung up whose principals feel they can be more creative and less wasteful and still serve clients' needs by tapping into well-cultivated networks of talented freelance specialists. For these designers, their entrepreneurial spirit nourishes their artistic vision and vice versa; mixing up their client bases, they do what they can to avoid becoming exploited partners with entertainment conglomerates who trade prestige for abusive payment practices or unreasonable demands. "We're leaner but more flexible," explains Petrula Vrontikis, one of several designers featured in this volume whose studio fits this emerging model. "We're not locked-in in any way, so to each project we can bring a design solution with its own special twist. Our set-up allows for genuinely personal service and truly meaningful—and intelligent—relationships between clients and designers."

Somi Kim, a principal of the similarly organized ReVerb studio, points out that in this end-of-the-century era of tremendous change, the term graphic design itself, as it is still used, "is based on old models of media production and visual communication." Thus, ReVerb attracts clients precisely because its members—Kim, Lisa Nugent, Susan Parr, and other contributors—offer a new breed of design studio as think tank with its new-fangled, media-savvy, culturally sensitive outlook, and services. "We're image consultants or creative producers," Kim says, "who catalyze, mix, and ferment; we scan or decode the cultural landscape and take selective core samples in order to develop strategic visual lexicons for our clients."

Sharing a kindred spirit, other Los Angeles designers are exploring—and redefining—what the applications of graphic design can and should be. Again, belying the sense of disassociation that an automobile-bound lifestyle in an environment of centerless urban sprawl might suggest, designers like Kaplan, Anne Burdick, Michael Worthington, and Denise Gonzales Crisp have forged an idea-

Exhibition catalogue for Armand Hammer Museum and Cultural Center
ART DIRECTOR: Somi Kim
DESIGNERS: Somi Kim, Beth Elliot, Jérome Saint-Loubert-Bié

Digital Campfires *layouts*
ART DIRECTORS: Somi Kim, Lisa Nugent
DESIGNERS: Somi Kim, Lisa Nugent, Winnie Li

nurturing community whose goal, as Kaplan describes it, "is not to have conventional staffs of employees, principals, or hierarchies, but rather to create opportunities for collaboration."

Crisp describes her Super Stove! design firm, for example, as "an independent studio dedicated to working with non-profit or break-even organizations" whose projects offer opportunities to explore "graphic design's edges and in-betweens." This helps explain her involvement with experimental, independent publications such as *Plazm* and *Émigré*, and the fact that most of Super Stove!'s efforts are offered on a volunteer basis. Like Crisp, many of the designers featured here write about and teach design, too; influential local schools where they have studied, like the California Institute of the Arts, the Art Center College of Design, and the Otis College of Art and Design, now provide forums in and from which these

Offramp *layout*
ART DIRECTOR: Somi Kim
DESIGNER: Denise Gonzales Crisp

artist-thinkers can promulgate their theories, observations, aspirations, and critiques.

These ideas and many others—some spontaneous and impulsive, some poetic or amusing, and still others studious and purposeful—take visible shape in the varied, wide-ranging and pace-setting selections of works from the portfolios of thirty-five Los Angeles-based designers or design studios that have been brought together in these pages. To examine them is to savor, in a very special form, something of the distinctive energy and creative spirit that are part of California's—and, specifically, of Los Angeles'—enduring allure. This is graphic design whose makers come to their work with respect for principles and lessons tried, true and, relatively speaking, old—and with excitement about their ongoing adventure as pioneers, in this ever-evolving field, of the unpredictable, eye-opening, trail-blazing new.

PRINCIPALS: Sean Adams,
Noreen Morioka
FOUNDED: 1993
NUMBER OF EMPLOYEES: 5

9348 Civic Center Drive
Suite 450
Beverly Hills CA 90210
TEL (310) 246-5758
FAX (310) 246-5750

ADAMS MORIOKA, INC.

Among the daunting thickets of computer-tortured type and dense, digitally conjured-up multi-layers of blurred, blended, and tinted images, at least one Los Angeles-area portfolio makes the case for clean, readable design, both in concept and execution. It counterbalances a reigning style that often seems to favor a clutter-happy, theory-fueled aesthetic. Respected for its playfulness and its clarity, Sean Adams' and Noreen Morioka's work for blue-chip clients—Disneyland, Samsung Electronics, Japan Airlines, the Gap—and cultural institutions—UCLA, the J. Paul Getty Museum of Art—reflects the forward-looking spirit of nineties-era design without getting bogged down in its stylistic pretensions. There is "power in restraint," Adams has observed of the studio's design solutions in which bold color figures prominently, as do copious white space and big, solitary images used iconographically, with retro nuances, to convey as much meaning as more complex compositions. Adams and Morioka, who met as students at CalArts in the early 1980s and worked together in some of the same offices, including that of Los Angeles innovator April Greiman, call themselves "information brokers" rather than graphic designers; their virtual-office operation routinely brings in outside collaborator-experts in various fields on a project-to-project basis. While not exactly minimalist, their work is purposefully underdesigned. They make a point of paring down, they say, because "the audience is listening, and they know when they are being manipulated."

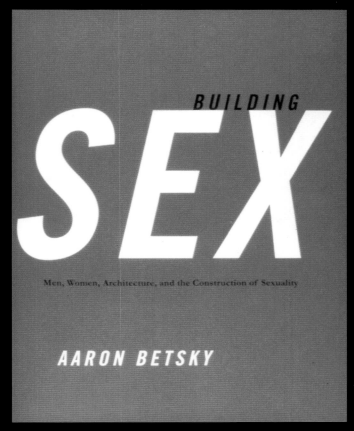

BUILDING
SEX

Men, Women, Architecture, and the Construction of Sexuality

AARON BETSKY

A hint of pattern, a handful of photo images, and a few well-chosen colors characterize a typical selection of Adams Morioka designs, including: the cover of design writer Aaron Betsky's book, *Building Sex*; a poster for a film festival; and a poster for a program of conferences on the theme of censorship.

CREATIVE DIRECTORS: Sean Adams, Noreen Morioka

PHOTOGRAPHY: Peter Baxter, *Slamdance poster;* Anthony Terumi, *censorship poster*

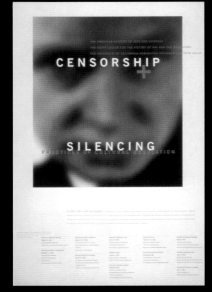

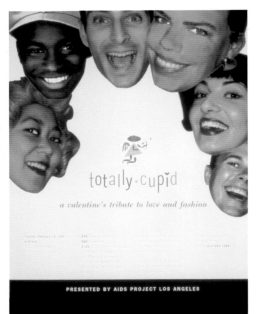

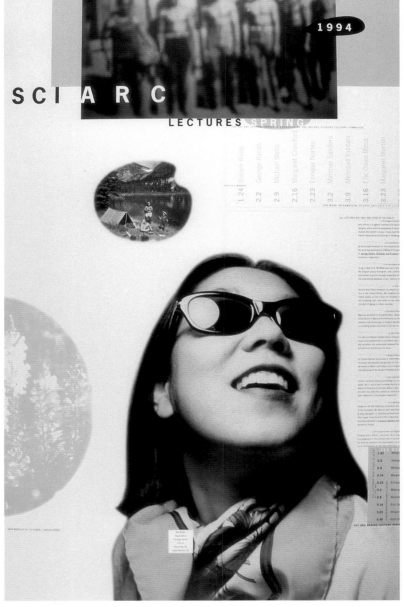

The playful air that wafts through much of Adams' and Morioka's work animates these posters that are composed of little more than silhouetted photo images, with a gentle splash of color, set against generous, bright white space. Noreen Morioka herself appears as a model in the Southern California Institute of Architecture poster; the silhouetted heads in the AIDS Project Los Angeles (APLA) poster echoes a common illustration style of the 1940s and 1950s.

CREATIVE DIRECTORS: Sean Adams, Noreen Morioka

PHOTOGRAPHY: Anthony Terumi, *APLA poster*

The cover of this booklet for UCLA's summer session, classically modern in its freshness and simplicity, seems to take a page from the Paul Rand stylebook. The use of primary colors and basic shapes is clever and effective; a big red dot evokes the summer sun, a blue line suggests the ocean, and the broad yellow field brings to mind the famous sandy beaches of southern California.

CREATIVE DIRECTORS: Sean Adams, Noreen Morioka
ILLUSTRATION: Sean Adams

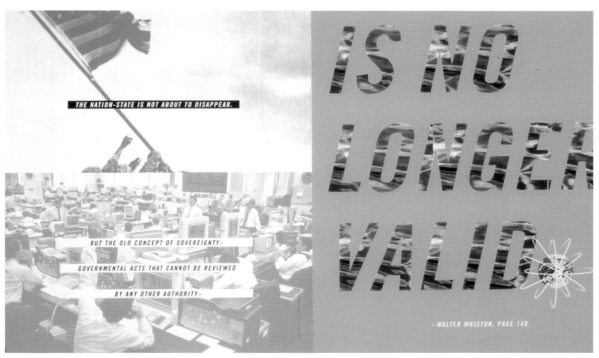

The tone and elements of Adams' and Morioka's distinctive style, with its humor and hip, self-consciously referential imagery, find a perfect home in the pages of *Wired* magazine, for which the designers created these two sets of thematically linked layouts.

CREATIVE DIRECTORS: Sean Adams, Noreen Morioka
ART DIRECTOR, *WIRED*: John Plunkett

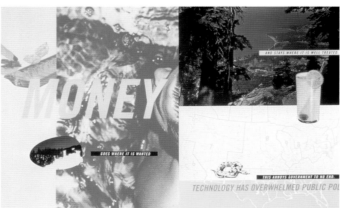

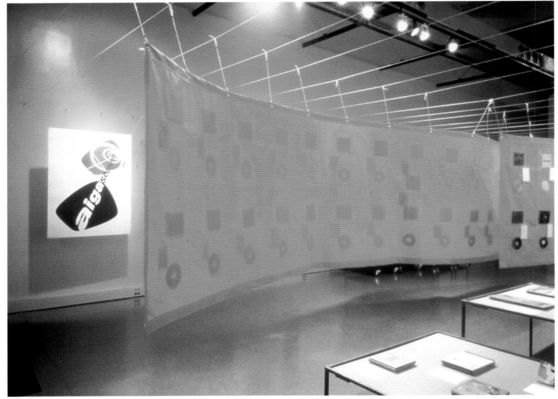

Adams and Morioka's catalog and
installation design for an exhibition
called *Sound Off*, sponsored by
the American Institute of the
Graphic Arts, boasts their signature
bold-color palette and an ingeniously
simple, suspended-fabric curtain
wall for the display of CD covers and
their accompanying discs.

CREATIVE DIRECTORS: Sean Adams,
Noreen Morioka
COORDINATOR: Gabriela Mirensky

PRESENTED BY THE AMERICAN INSTITUTE OF GRAPHIC ARTS
SPONSORED BY APPLETON PAPER

PRINCIPAL: Tom Haskins
FOUNDED: 1993
NUMBER OF EMPLOYEES: 8

8952 Ellis Avenue
Los Angeles CA 90034
TEL (310) 202-0140
FAX (310) 202-9021

BUZ DESIGN GROUP

Buz Design Group, a small firm, prides itself on bringing strength—in colorful, somewhat unexpected ideas—to its work for a roster of well-known corporate clients, including Infiniti, Sega, Speedo, and Edison International, a global developer of utility projects. Part of Buz Design's strategy is to inject a sense of fun and freshness—without gimmicks—into more conventional, admittedly formal assignments: press kits, invitations for special events, and promotional materials. At the same time, the group's designers respect the need for formal touches, when appropriate, as in their series of annual Infiniti press kits, whose linen-wrapped binders suggest elegant reference books. At its most exuberant, Buz Design's work eschews strict formulas from one project to the next and routinely makes room for color, texture, and interesting details, including unusual die-cuts, metal-screw bindings, and specially shaped cardboard cartons for consumer-product packaging. Sturdy, straightforward solutions characterize the range of Buz Design's work, from corporate identity schemes to packaging for infants' toys.

Reminiscent of a reference book, this press kit in a binder-and-slipcase format, with a CD-ROM insert, brings contemporary elegance to a substantial corporate assignment for Infiniti autos.
DESIGNERS: Tricia Rauen, Aaron Atchison, Kelli Kunkle-Day
CREATIVE DIRECTOR: Tricia Rauen

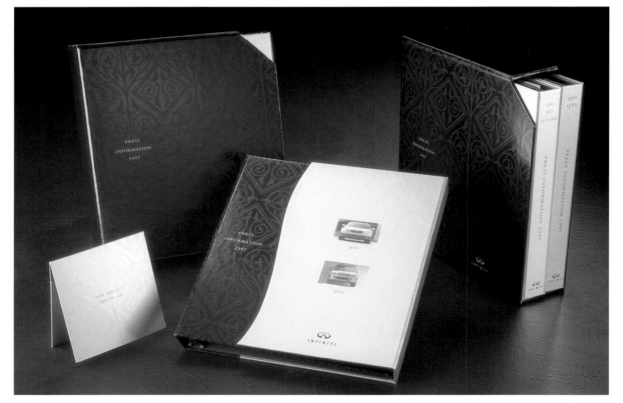

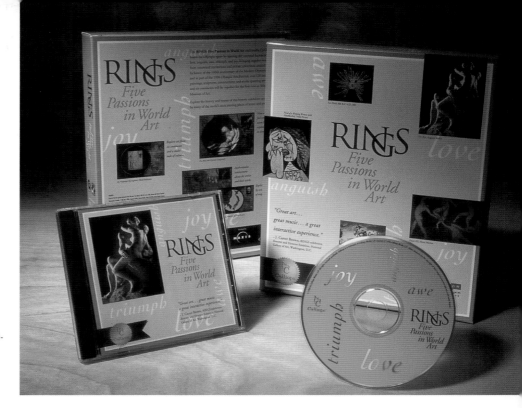

The box packaging for a Calliope CD-ROM of an art exhibition succinctly presents its five principal themes.
DESIGNER: Kelli Kunkle-Day
CREATIVE DIRECTOR: Tricia Rauen

A capabilities brochure for an international utilities developer emphasizes clarity in a straightforward corporate project.
DESIGNER: Kelli Kunkle-Day
PHOTOGRAPHY: Greg O'Laughlin
CREATIVE DIRECTOR: Tricia Rauen

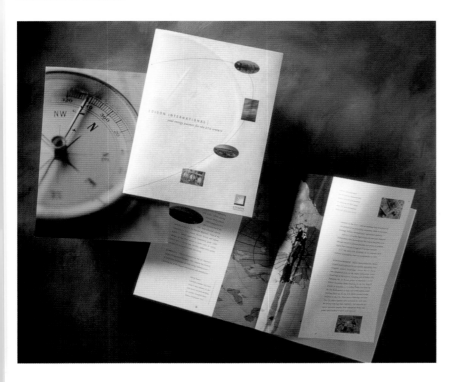

Logo for Adelson Entertainment, a producer of TV movies.
DESIGNERS/ILLUSTRATORS: William Kent, Tricia Rauen
CREATIVE DIRECTOR: Tricia Rauen

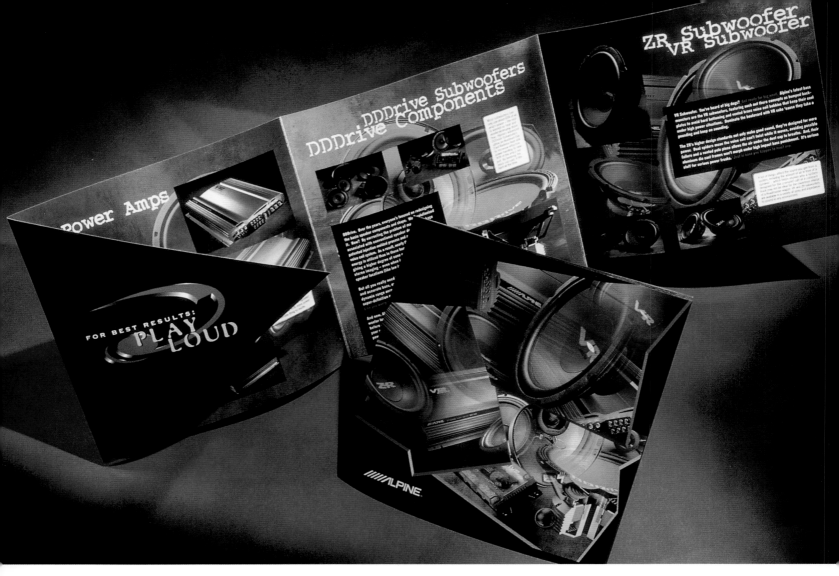

A brochure for Alpine car-stereo
products brings brightness and
dynamism to an otherwise
colorless, static subject: speakers.
DESIGNER: Aaron Atchison
PHOTOGRAPHY: Anthony Nelson
CREATIVE DIRECTOR: Tricia Rauen

Logo for Node Warrior Networks,
an Internet service provider.
DESIGNER/ILLUSTRATOR: Rose Hartono
CREATIVE DIRECTOR: Tricia Rauen

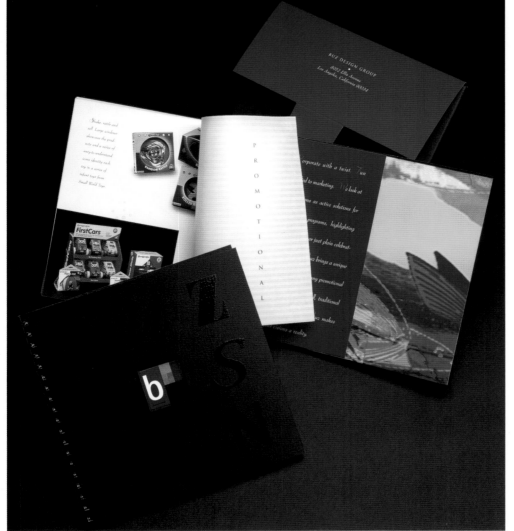

Buz Design Group's own
spiral-bound promotional booklet.
DESIGNER/CREATIVE DIRECTOR:
Tricia Rauen
ILLUSTRATOR: Rose Hartono

PRINCIPALS: Mateo Neri,
Bryan Dorsey
FOUNDED: 1994
NUMBER OF EMPLOYEES: 14

1522 Cloverfield Boulevard
Suite E
Santa Monica CA 90404-3502
TEL (310) 264-2424
FAX (310) 264-2430

COW.

The largest part of any design job is the organization of information—the visual, formal, quantitative, and qualitative. Effective graphic design is the visible expression of such ordering principles in the service of the information they convey. For cow.'s co-founders, Art College of Design graduates Bryan Dorsey and Mateo Neri, no amount of technobabble or high-tech gimmickry can substitute for the clarity of a basic, well-thought-out structure. Likewise, the collaborators at cow., who specialize in computer interfaces for Web sites and CD-ROMs, focus as much on their work's looks as they do on the underlying programming logic that brings their designs to life. In the new-media field, where graphic design and technology (specifically, computer programming) are cross-pollinating as never before, cow.'s "keep it simple" motto is reflected in its often bold-colored, neatly laid-out interface screens. Similarly, as one evaluation of cow.'s work noted, their users are "always centered around one context, and all the imagery and content is brought to [them], as opposed to linking from page to page." It's no surprise, then, that Dorsey and Neri use children's wooden building blocks to form three icons that refer to their creativity's motivating themes: a cow for the natural, a face for the human, and a rocket ship for the technological.

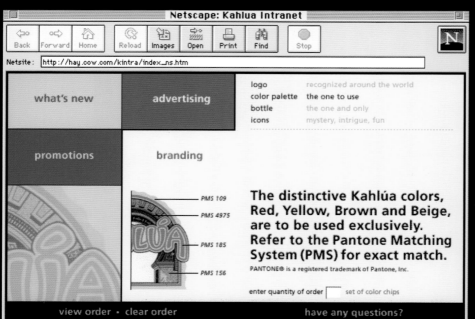

Kahlúa's intranet by cow. allows a user to access everything within the site without ever feeling lost. Its simple, rectilinear layout works in conjunction with a gear-like interface that circles itself as a user chooses main categories.

ART DIRECTOR/LEAD DESIGNER:
Kendrick Lim

CREATIVE DIRECTORS: Mateo Neri;
Lisa Carlssen, Kahlúa/Lois/EJL;
Andrea Giambrone

ENGINEERS: Samuel Goldstein,
Jonathan Santos, Tammy Mckean

PROGRAMMER: Carl Brinkman

Kahlúa's Web site echoes the functional spirit of its in-company intranet, with a warm, vibrant color palette linked to that of the liqueur's packaging.

ART DIRECTOR/LEAD DESIGNER:
Bryan Powell

CREATIVE DIRECTORS: Mateo Neri; Lisa Carlssen, Kahlúa/Lois/EJL; Andrea Giambrone

ENGINEERS: Samuel Goldstein, Jonathan Santos, Tammy Mckean

PROGRAMMER: Carl Brinkman

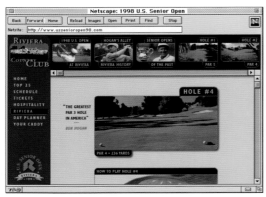

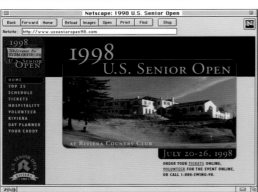

At first glance somewhat more conservative in character than its other creations, cow.'s Web-site for the 1998 U.S. Senior Open demonstrates a smooth integration of a more conventional look and its "keep-it-simple" interface, in which players' photo portraits serve as click-on, data-yielding icons.

ART DIRECTOR/LEAD DESIGNER:
Bryan Powell

CREATIVE DIRECTOR: Mateo Neri

ENGINEERS: Samuel Goldstein,
Jonathan Santos

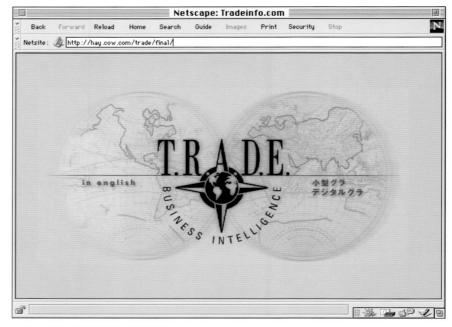

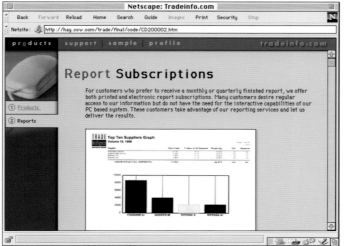

cow.'s Web site for Trade allows users to easily find import-export data. A photo in the upper left-hand corner of each screen reminds users of the information category they are accessing. A high-contrast color palette and sans-serif type aid legibility.

ART DIRECTOR/LEAD DESIGNER/HTML:
Bryan Powell

CREATIVE DIRECTOR: Mateo Neri

ENGINEER: Samuel Goldstein

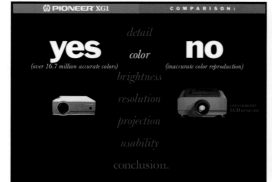

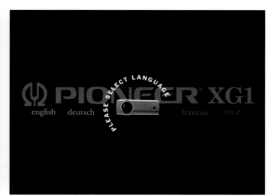

Screens from a sales-tool
CD-ROM for Pioneer Electronics.
ART DIRECTOR/LEAD DESIGNER:
Hiro Niwa
CREATIVE DIRECTOR: Bryan Dorsey
PHOTOGRAPHY: Syko Song
3-D ANIMATION: Lance Funston
PROGRAMMER: Thierry Benichou

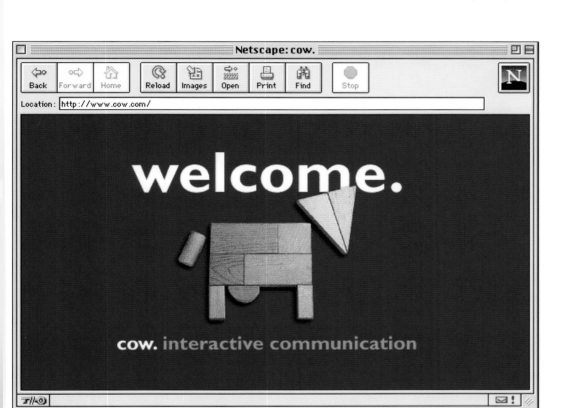

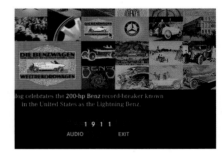

cow. created this marketing
CD-ROM for Mercedes-Benz, in
whose multi-unit screen layouts
the automaker's new E-class
cars are featured. Overlapping
headlines and a rich tapestry of
images evoke a sense of
the brand's long, full history.

Its uncluttered looks and ease of
use are aspects of cow.'s own Web
site, by means of which the
studio announces and describes its
services and design philosophy.
ART DIRECTOR/LEAD DESIGNER: David Lai
CREATIVE DIRECTOR: Bryan Dorsey
PROGRAMMER: Diana Brickell
ENGINEERS: Samuel Goldstein,
Jonathan Santos

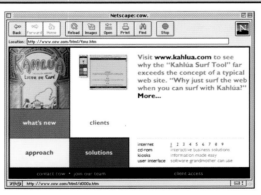

PRINCIPAL: Steve Curry
FOUNDED: 1988
NUMBER OF EMPLOYEES: 10

1501 South Main Street
Venice CA 90291
TEL (310) 399-4626
FAX (310) 399-8524

CURRY DESIGN, INC.

Often there comes a point in the evolution of any strong, ambitious form of artistic expression at which its attitudes, aspirations, manners, and vocabulary—this last factor is something that, for graphic designers, is primarily visual—come together in a recognizable style. By this time, those who embrace and interpret a style may be seen to contribute to its elaboration as much as its originators themselves. Much of Curry Design's work displays a firm, skillful command of what has become a familiar, computer-driven, postmodern graphic-design style now encountered in everything from shopping bags to annual reports. But Curry Design's work also seamlessly assimilates all the classic lessons and conventions of the broader corporate vernacular, going back at least to the seventies, in designs that speak today's established—and still-evolving—visual language with an eloquent tone and a sense of high style. Thus, projects like his dual, self-promotional calendar for his own studio and Nationwide Papers, and his packaging of CD-ROM training materials for Nissan Motor Corp., and his company's self-promotional gift box of wine, with its custom-made label and wrapping, all reach for and strike the same notes in perfect pitch.

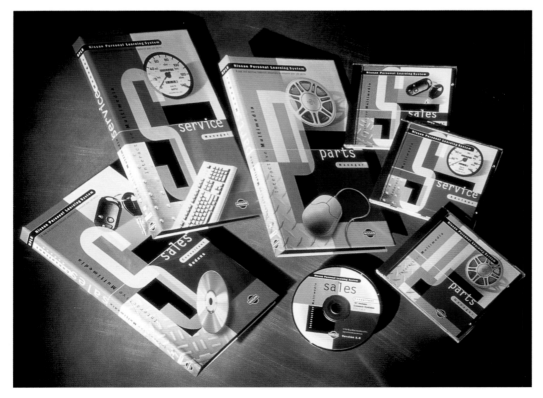

Steve Curry's studio produced this series of packages for interactive CD-ROM training materials for Nissan Motor Corp.
ART DIRECTOR: Kris Tibor
CREATIVE DIRECTOR: Steve Curry
PHOTOGRAPHY: Marcelo Coelho

Curry interprets and elaborates the contemporary corporate vernacular in a wide range of projects, including these self-promotional items for the designer's own studio plus other companies. Spiral-bound calendar in cardboard box for Curry Design, Inc., Nationwide Papers, B & G House of Printing, and MCO photography.

ART DIRECTOR: Jason Scheideman
CREATIVE DIRECTOR: Steve Curry
PHOTOGRAPHY: Marcelo Coelho

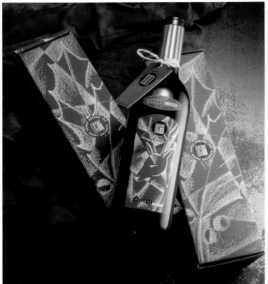

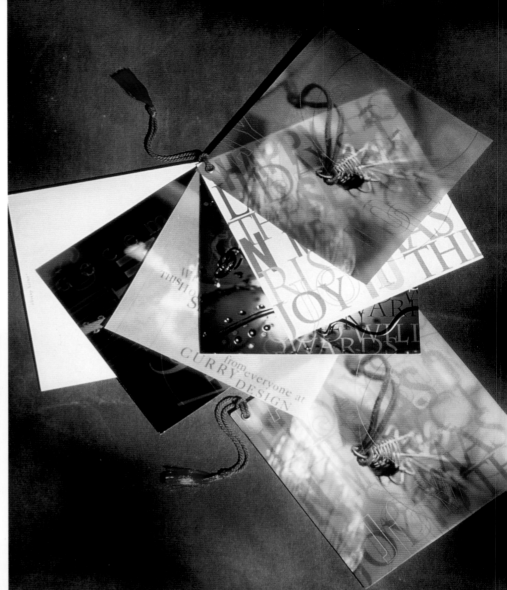

These greeting cards (highlighting the work of Primary Color, a printing company) and custom-made gift boxes of wine are promotional items sent out by Curry Design to its clients.

ART DIRECTORS: Steve Curry, *cards*; Chris Ragaini, *bottle*

CREATIVE DIRECTOR/ILLUSTRATOR: Steve Curry

PHOTOGRAPHY: Mike Lorrig, Bill Vanscoy

As these examples of annual reports, promotional materials, and packaging show, Curry Design's work seamlessly assimilates many of the classic conventions of the broader corporate vernacular in designs that speak today's visual language with a sense of high style. *McDonnell Douglas Finance Corp. Annual Report:*

ART DIRECTOR: Pyong Mun
CREATIVE DIRECTOR: Steve Curry
PHOTOGRAPHY: Marcelo Coelho
Nissan Motor Corp. quarterly booklets and counter cards:
ART DIRECTORS: Mike Esparanza, Debbie Kawamoto
CREATIVE DIRECTOR: Mike Esparanza
Nissan Motor Corp. Altima brochures:
ART DIRECTOR: Chris Ragaini
CREATIVE DIRECTOR: Steve Curry
Columbia TriStar materials:
ART DIRECTORS: Jason Scheideman, Chris Ragaini, Mike Esparanza
CREATIVE DIRECTOR: Steve Curry
Package for Filenet Corp.:
ART DIRECTOR/ILLUSTRATOR: Jason Scheideman
CREATIVE DIRECTOR: Steve Curry
PHOTOGRAPHY: Marcelo Coelho

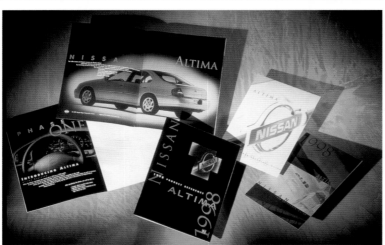

PRINCIPAL: Daniel H. Tsai
FOUNDED: 1996
NUMBER OF EMPLOYEES: 4

9005 Cynthia Street
Suite 104
West Hollywood CA 90069
TEL (310) 273-8720
FAX (310) 273-8729

DANIEL H. DESIGN

The portfolio of the young designer Daniel H. Tsai, who brings a background in both fine art and the natural sciences (biology and zoology) to his work, displays a flair for organizing texts and images that is studiously neat and attractively stylish. Tsai, who once traveled to Africa, England, Mexico, and around the United States to do wildlife-conservation research, studied at the Art Center College of Design in Pasadena. There, he switched his major from fine art and illustration to graphic design after taking typography courses taught by Simon Johnston (of Praxis: Design) and Rebeca Méndez, to whom Tsai largely credits his passion for design. As a capable stylist, Tsai has assimilated the vocabulary of multi-layered images and fluid, mixed-typeface typographic treatments that have become the common visual currency of everything from bank brochures to TV commercials for food and soap. But Tsai tweaks this now-prevalent vernacular with a penchant for antique-looking typefaces and for conjuring up a sense of the historic or the romantic. Ever the science aficionado, he often borrows from—or creates original graphics to emulate—old engravings that effectively allude to culture or technology with a gentle, poetic air.

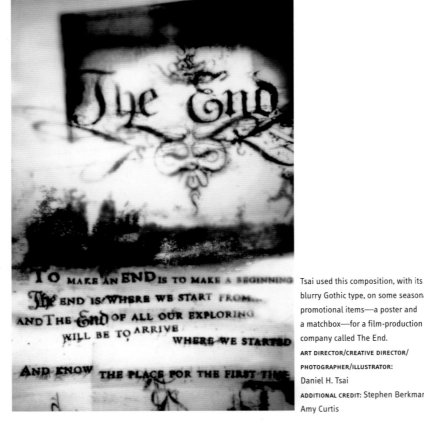

Tsai used this composition, with its blurry Gothic type, on some seasonal promotional items—a poster and a matchbox—for a film-production company called The End.
ART DIRECTOR/CREATIVE DIRECTOR/
PHOTOGRAPHER/ILLUSTRATOR:
Daniel H. Tsai
ADDITIONAL CREDIT: Stephen Berkman,
Amy Curtis

These screen shots from a presentation entitled *Design Challenges in Virtual Worlds* that Daniel H. Tsai created for a speaker from Microsoft employ the vocabulary of multi-layered images and fluid, mixed-typeface typographic treatments that have become the common visual currency—call it a style—of so much graphic design today.

ART DIRECTOR: Linda Stone
DESIGNER: Daniel H. Tsai
CONTENT PROVIDER: Chris Liles

Graphed versions of color-photographed, still-life forms, and luscious photo images are the key elements of this self-promotional calendar produced by Daniel H. Design.
ART DIRECTOR/DESIGNER: Daniel H. Tsai
PHOTOGRAPHY: Robert Caldwell
CREATIVE CONSULTANT: Simon Johnston/Praxis: Design

Tsai often creates mood-evoking works, like this presentation piece for Amica, an insurance company, in which art and design come together. They are used by directors or producers, who show them to clients and advertising agencies with whom they are involved in the production of TV commercials to give their colleagues a tangible, visible sense of their creative vision for a particular spot.
DIRECTOR: Anouk Bessen
CREATIVE DIRECTOR/PHOTOGRAPHER/ILLUSTRATOR: Daniel H. Tsai
DESIGNERS: Daniel H. Tsai, Karen Orilla

TUNNELVISION

A spiral-bound promotional booklet for Tunnelvision describes this program that sponsors art in subway systems. In this form of "motion" pictures, subway riders look out their windows at train-tunnel walls, on which painted images flicker as trains roll by.

ART DIRECTOR/DESIGNER/PHOTOGRAPHER/ILLUSTRATOR: Daniel H. Tsai
CREATIVE DIRECTORS: Laura Howard, Charles Watson
ASSISTANT DESIGNER: Luis Jaime
COPYWRITER: Laura Howard

Tsai's numerous logo designs include these for Microsoft's online Comic Chat service; for the Living Desert, a zoo in Palm Springs; and for *Point of View Inc.*, an interactive CD-ROM company.

ART DIRECTOR/CREATIVE DIRECTOR/ ILLUSTRATOR: Daniel H. Tsai

DESIGN CONSULTANT: Anthony Lion, *Point of View logo Inc.*

PoINT OF VIEW INC.

With a background in both fine art and the natural sciences, Daniel H. Tsai often borrows from—or creates original graphics to emulate—old engravings that effectively allude to culture or technology with a gentle, poetic air. He does so in these screen shots from a presentation created for Microsoft.

ART DIRECTORS/DESIGNERS: Daniel H. Tsai, Daniel Garcia/Aahbüllay Design

CREATIVE DIRECTOR/ILLUSTRATOR: Daniel H. Tsai

Words set in a serif typeface that triggers a strong sense of history and tradition float and swim against a montage of images in a TV commercial for California Federal.
DIRECTOR: Anouk Bessen
CREATIVE DIRECTOR/TYPOGRAPHY DIRECTOR: Daniel H. Tsai
ADVERTISING AGENCY: Richards Group

PRINCIPALS: Chuck Pelly,
Raymond Carter, Dean Ryan
FOUNDED: 1972; graphics
department, 1998
NUMBER OF EMPLOYEES: 70;
graphics department, 7

2201 Corporate Center Drive
Newbury Park CA 91320-1421
TEL (310) 499-9590
FAX (310) 499-9650

DESIGNWORKS/USA

A subsidiary of BMW in North America, this large firm has created designs for furniture, bicycles, medical equipment, and cars; it has also become known for interactive communications-design work that can be as inviting in its implementation for end-users as it is carefully considered in its form and structure. Designworks/USA prides itself on the rigorously cross-disciplinary approach its designers take to producing everything from logos—for products, services, special events—to packaging for skateboarders' helmets. In particular, its Advanced Communications Department, led by Alec C. Bernstein, has given considerable thought to the changing needs of corporate clients in a digital world. Its members pay special attention to the computer-interface element, with or without a screen, that has become a feature of so many products, from microwave ovens and automatic-teller machines to complex surgical equipment. Designworks/USA's advanced-communications team of collaborating experts in illustration, painting, music composition, software engineering, and literature also creates trade-show videos and other kinds of presentations. With their theoretical component rooted in a down-to-earth, user-friendly concern for practical function, many of Designworks/USA's projects are exemplars of the best spirit of design as a process of creative organization.

the image will become more IMPORTANT THAN THE object itself,

website

interface

controls

There is a square. There is an oblong. The players take the square and place it upon the oblong.
They place it very accurately. They make a perfect dwelling-place.

philosophy

We have made oblongs and stood them upon squares.
This is our triumph. This is our consolation.

Virginia Woolf

Sample screens from the interface demo promoting the firm's own Advanced Communications Department exude the logical-structural approach that is its hallmark.
DIRECTOR: Alec C. Bernstein
CREATIVE DIRECTOR: Monika Zych
PROGRAMMER: Laura Robin

Bright, punchy colors printed on
corrugated cardboard give packaging
for skateboarders' helmets an
appropriately rugged air.
ART DIRECTOR: Aris Garabedian
PHOTOGRAPHY: Darren Yasukochi

pHY∫iCAL gENiU∫

These are logos for John Deere's industrial division (opposite page); for Physical Genius, a portable computer for reluctant fitness fans; for an in-flight, satellite-TV service; and for a BMW-sponsored symposium.
DESIGNER: Cheryl Pelly

Type, images, and symbols stand out dramatically against dark backgrounds in an interface project for Apple Computer.
CREATIVE DIRECTORS: Alec C. Bernstein, Taylor Wescoatt

Designworks/USA's Advanced Communications Department brought a computer-generated sense of layering—of kinds and levels of information, of graphic elements—to a CD-ROM for a United Nations conference. **ART/CREATIVE DIRECTORS:** Rebecca Birney, Monika Zych, Ming Chen

PRINCIPAL: Douglas Oliver
FOUNDED: 1983
NUMBER OF EMPLOYEES:
Los Angeles, 8; St. Louis, 4

2054 Broadway
Santa Monica CA 90404
TEL (310) 453-3523
FAX (310) 453-6290

DOUGLAS OLIVER
DESIGN OFFICE

The expansive feeling suggested by the designer-white walls and the 25-foot-high, barrel-shaped, natural-wood ceiling of Douglas Oliver's offices hints at the smooth blend of corporate savvy and good-natured, human warmth that come together visibly in the work of this transplanted Midwesterner and his associates. "We have a conservative look that plays surprisingly well in Los Angeles," Oliver has said. For many years, Douglas Oliver Design Office has specialized in creating annual reports that have given an eloquent, contemporary tone to the obligatory, nuts-and-bolts presentation of corporate data. In Oliver's work, type is clear and uncluttered, photos or artwork are crisp and bold, and flashiness gives way to a recognizable sense of focus that has attracted clients from a wide range of industries, including communications, defense, entertainment, food, and retail services. An alumnus and now instructor at Pasadena's Art Center College of Design, Oliver is a consultant to the Mead Corporation and serves on its Design Council. With a strong interest in the materials of graphic design, his firm also counts many paper and printing companies among its clients. Most recently, it opened a branch office in St. Louis.

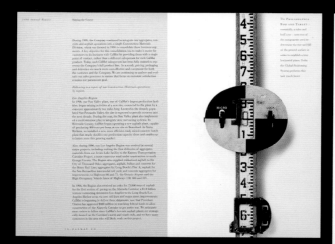

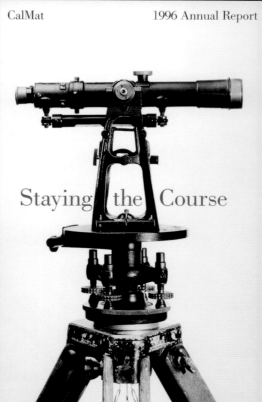

Crisply silhouetted, detail views of specialists' tools, and a solid, grid-based text layout make for a visually well-ordered, serious-minded annual report for a mining and minerals company.
ART DIRECTOR: Douglas Oliver
DESIGNER: Steve Sieler
PHOTOGRAPHY: Elyn Marton

People are talking

Stark, black-and-white contrasts reinforce the reportorial feeling of layouts in an annual report for a telecommunications company.
ART/CREATIVE DIRECTOR: Douglas Oliver
PHOTOGRAPHY: Jeff Corwin

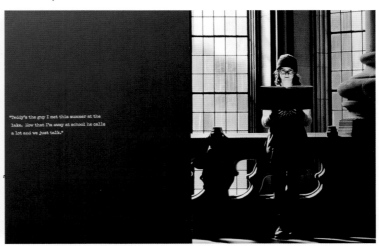

"Teddy's the guy I met this summer at the lake. Now that I'm away at school he calls a lot and we just talk."

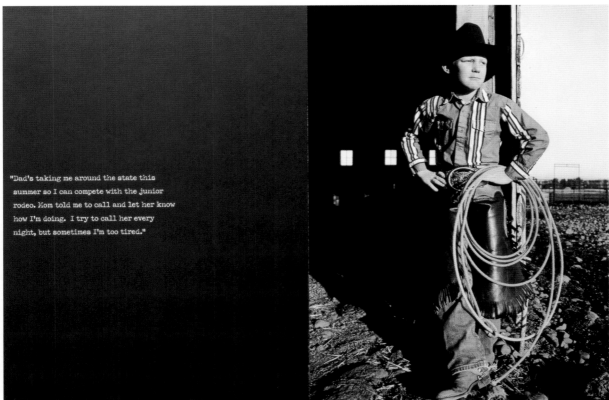

"Dad's taking me around the state this summer so I can compete with the junior rodeo. Mom told me to call and let her know how I'm doing. I try to call her every night, but sometimes I'm too tired."

Northrop Grumman Corporation

1996 Annual Report

A symbol-chart of aircraft and submarines in a defense contractor's annual report recalls the look and feel of a war-history book.

ART/CREATIVE DIRECTOR: Douglas Oliver

ILLUSTRATORS: Rosemary Webber, Dusty Deo

PHOTOGRAPHY: Bill Varie, John Amrhein

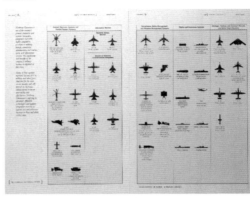

PAGE TWENTYFIVE } 25. 1996 [NORTHROP GRUMMAN] annual report

Operations Review

Northrop Grumman participates on many key military and commercial programs within its primary business areas. These systems will remain operational for several decades, and the company's incumbent position creates a competitive advantage in capturing new and follow-on business. As reflected in its 1996 operations, Northrop Grumman is developing and applying affordable, advanced technology solutions to strengthen its market position and meet new customer requirements.

Electronics One clear characteristic of military forces in the future will be their reliance on electronics. Although the Administration's defense budget is essentially flat over the next five years, various studies indicate that the electronics segment will increase as a percentage of the total budget. Faced with budget realities, defense leaders are analyzing the fit between national security strategy and future missions. As the military services continue to look for ways to achieve greater precision, flexibility, and survivability, defense electronic systems become increasingly important. Experience in large-scale systems integration of surveillance, battle management, and strike platforms—including the electronic linkages among these systems—positions companies such as Northrop Grumman to meet emerging military requirements.

Surveillance and Battle Management
Collecting, organizing, and delivering key tactical and strategic information to decision makers and operational forces on a near-real-time basis are among the principal challenges of future military operations. Airborne platforms, including the E-8 Joint STARS surveillance and battle management system, the E-2C airborne early warning and control (AEW&C) system, and the E-3 Airborne Warning And Control System (AWACS), will fill many of the needs of domestic and foreign customers — including warfighting requirements, peace enforcement, treaty verification, and crisis management. As prime contractor for the E-8 and E-2C and major sensor provider for the E-3, Northrop Grumman is working with its customers to combine and enhance existing platforms and to improve data processing techniques, thus enabling systems to distribute information more quickly to combat elements that immediately affect the battle.

{ JOINT STARS }

fig. 8
E-8C
JOINT SURVEILLANCE
TARGET ATTACK
RADAR SYSTEM
[JOINT STARS]

Description: Detects, locates, classifies, and tracks fixed and moving ground forces, including jeeps and armored vehicles, as well as patrol boats and slow-flying rotary and fixed-winged aircraft, day or night, in all weather conditions.

Company Role: Prime contractor and radar sensor provider.

Customer: U.S. Air Force, U.S. Army.

Revenue: 1996 sales $606 million; potential revenue $6 billion through 2003.

In ground surveillance, Joint STARS proved to be an essential surveillance and battle management asset during 1996 NATO peacekeeping operations in Bosnia-Herzegovina, offering allied commanders an unprecedented view of fixed and moving ground forces, greatly increasing situational awareness. Northrop Grumman's Electronics and Systems Integration Division (ESID) is prime contractor for Joint STARS, and the system's radar sensor is produced by the company's Electronic Sensors and Systems Division (ESSD).

The company is leading a team that is offering Joint STARS to NATO to meet its airborne ground surveillance requirements. Team members include some of the largest European

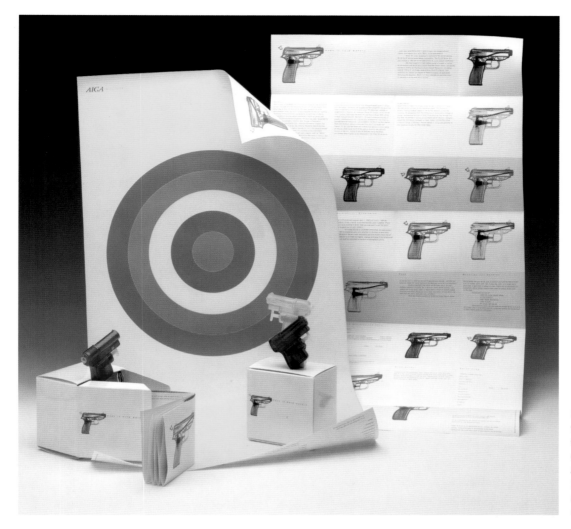

Bold colors and a simple target motif imbue a design for an AIGA competition entry form with whimsy.
ART DIRECTOR: Deanna Kuhlmann-Leavitt
DESIGNER: Michael Thede
PHOTOGRAPHY: Kathy Miller

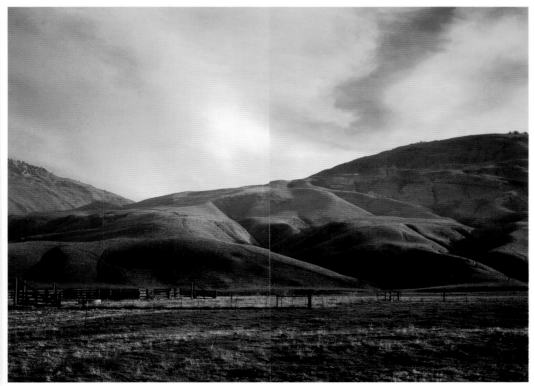

Full-bleed photo spreads and two-color handling of an interview-format text give a magazine-like character to this annual report for a ranch company.
ART DIRECTOR: Douglas Oliver
CREATIVE DIRECTOR: Jay Novak
ILLUSTRATOR: Michael Thede
PHOTOGRAPHY: Reed Kaestner

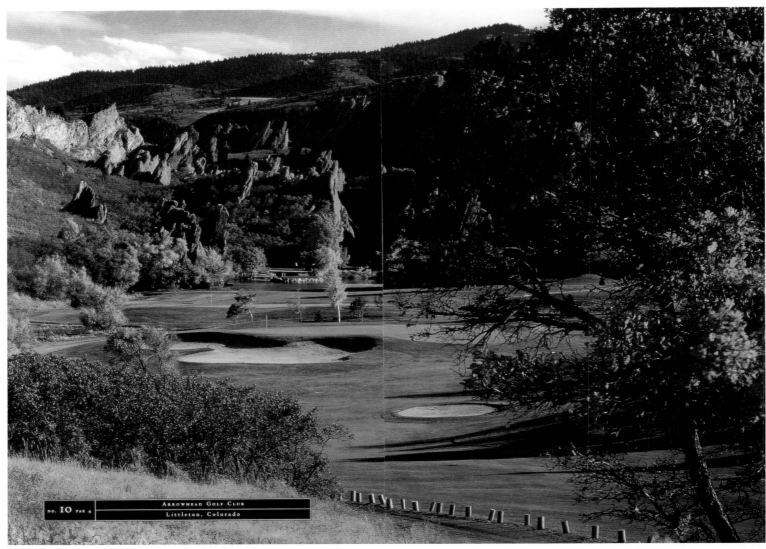

NO. 10 PAR 4 ARROWHEAD GOLF CLUB
Littleton, Colorado

Color-flecked papers give visual texture to the pages of an annual report for a golf-course development company.

ART/CREATIVE DIRECTOR:
Douglas Oliver

PHOTOGRAPHY: Aidan Bradley

An information-organizing visual-symbol system used in this catalog and on its accompanying CD-ROM shares the spirit of the data-management services that they describe.
ART DIRECTOR: Deanna Kuhlmann-Leavitt
DESIGNER: Michael Thede
PHOTOGRAPHY: Pierre-Yves Goavec

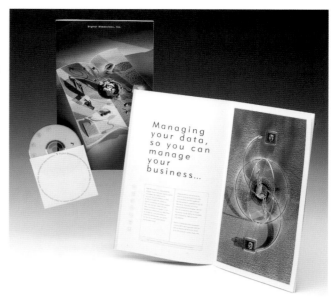

Sprightlier than some of the firm's more self-styled "conservative" designs, the Oliver team's information kit in a binder for the coated-board division of the Mead Corporation, uses saturated, primary-color hues on the cover shown, as well as inside. The effect is at once freshly engaging and solidly corporate.
ART/CREATIVE DIRECTOR: Deanna Kuhlmann-Leavitt
ILLUSTRATION: Dusty Deo, Rosemary Webber
PHOTOGRAPHY: Pete McArthur, Chris Shinn, Gary Faye

The Tool Box.

PRINCIPAL: Cole Gerst
FOUNDED: 1993
NUMBER OF EMPLOYEES: 1

2145 N. Screenland Drive
Burbank CA 91505
TEL (818) 846-7029
FAX (818) 656-6568

COLE GERST

Firmly rooted in the rich soil of pop-music packaging, Cole Gerst's work nods knowingly at such anonymous, decidedly unslick source material as American print jobbers' commercial art of the 1950s and 1960s, folk art, and outsider art. And although Gerst is keenly aware that record-album and CD packaging must seize a consumer's attention to help promote sales in a fiercely competitive field, his work for the independent labels Ichiban Records (Atlanta) and Alias Records (Burbank) has benefited from the assertive irreverence and deadpan irony that have been the hallmarks of rock-music graphics—and youth-oriented advertising in general—in the post-punk, MTV era. Counting the meticulous box-art maker Joseph Cornell and outsider artist Howard Finster among his influences, in his designs Gerst often uses drawn or painted—not computer-generated—artwork and hints at the touch of the hand. Extending his music-genre range, this year Gerst has begun art directing for House of Blues Entertainment, Inc.

Gerst's design for a 45-rpm single on the Let Down label uses an illustration and, in the era of the digital CD, keeps alive the tradition of the small vinyl record's collectible picture sleeve.

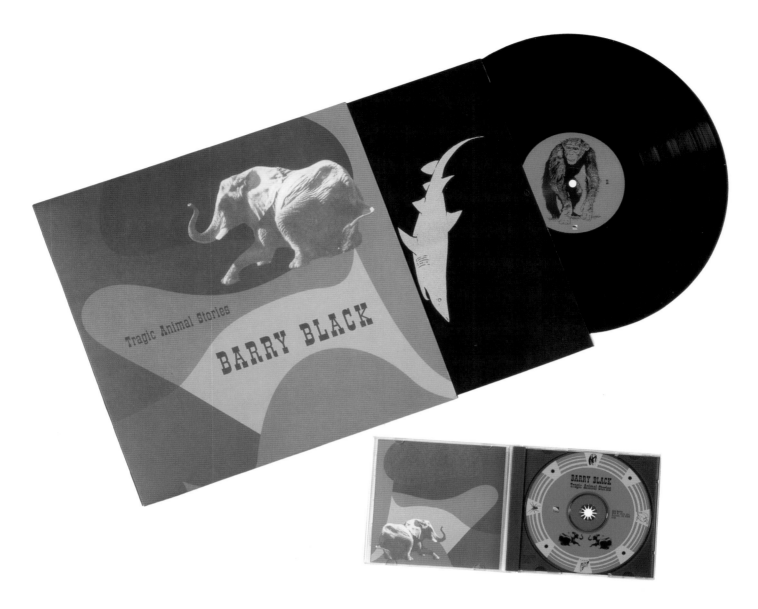

Handsomely stark and modern, Gerst's graphics for Barry Black's *Tragic Animal Stories* album (Alias Records) is as enigmatic as its songs, with titles like "The Horrible Truth About Plankton."

A techno-logo for the band's name and a free-floating hodgepodge of visual elements—an ambiguous background photo; a futuristic warrior toy; computer-generated, topographic forms—capture the trip-hop mood of Audio Active's self-titled album for Plusminus Recordings, an L.A.-based label.

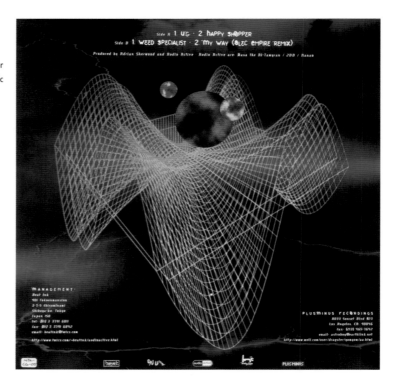

A sense of postmodern irony, with touches of Liberace luxe, rules in Gerst's promotional kit for Royaltone Studios, with photography by Edward Glover. Highlights include an emphatically elegant, cursive typeface, a fake-suede folder, and, inside, faux gold-leaf headers atop each insert describing the features of the recording facility.

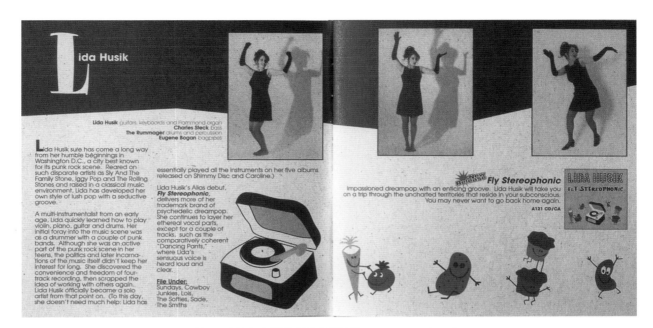

Lida Husik

Lida Husik guitars, keyboards and Hammond organ
Charles Steck bass
The Rummager drums and percussion
Eugene Bogan bagpipes

Lida Husik sure has come a long way from her humble beginnings in Washington D.C., a city best known for its punk rock scene. Reared on such disparate artists as Sly And The Family Stone, Iggy Pop and The Rolling Stones and raised in a classical music environment, Lida has developed her own style of lush pop with a seductive groove.

A multi-instrumentalist from an early age, Lida quickly learned how to play violin, piano, guitar and drums. Her initial foray into the music scene was as a drummer with a couple of punk bands. Although she was an active part of the punk rock scene in her teens, the politics and later incarnations of the music itself didn't keep her interest for long. She discovered the convenience and freedom of four-track recording, then scrapped the idea of working with others again. Lida Husik officially became a solo artist from that point on. (To this day, she doesn't need much help: Lida has essentially played all the instruments on her five albums released on Shimmy Disc and Caroline.)

Lida Husik's Alias debut, **Fly Stereophonic,** delivers more of her trademark brand of psychedelic dreampop. She continues to layer her ethereal vocal parts, except for a couple of tracks, such as the comparatively coherent "Dancing Pants," where Lida's sensuous voice is heard loud and clear.

File Under:
Sundays, Cowboy Junkies, Lois, The Softies, Sade, The Smiths

Now Release **Fly Stereophonic**
Impassioned dreampop with an enticing groove. Lida Husik will take you on a trip through the uncharted territories that reside in your subconscious. You may never want to go back home again.
A121 CD/CA

LIDA HUSIK
FLY STEREOPHONIC

At once a magazine and an expanded CD cover that contains a music-sampler disc, Gerst's *The Year of the Wagon* mail-order catalog for Alias Records packs a lot of fun and information into a small, easily accessible package.

Gerst hung out in an airport—and literally hung from an airplane—to shoot the dark runway photo on the cover of Archers of Loaf's *All the Nations' Airports* album (Alias Records). Boarding passes, arrival/departure boards, and safety information cards inspired Gerst and collaborating type designer Zuzana Licko's related designs.

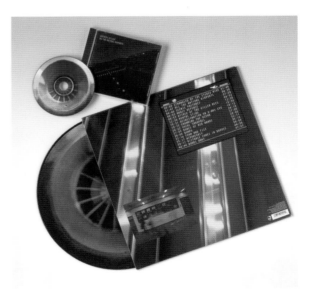

For this folk-flavored Alias Records tour poster for the band Trunk Federation, Gerst took his cue from the lead singer's love for the circus. The found-woodblock typeface evokes a sense of old, hand-pulled broadsheets, and the poster's bright inks are easy to see in dark clubs, where it is usually displayed.

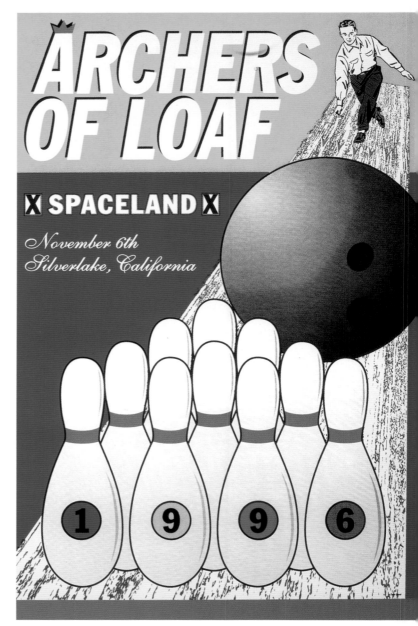

Gerst's crisply silk-screened poster for the band Archers of Loaf makes irreverent allusions to clip art and the commercial-art vernacular.

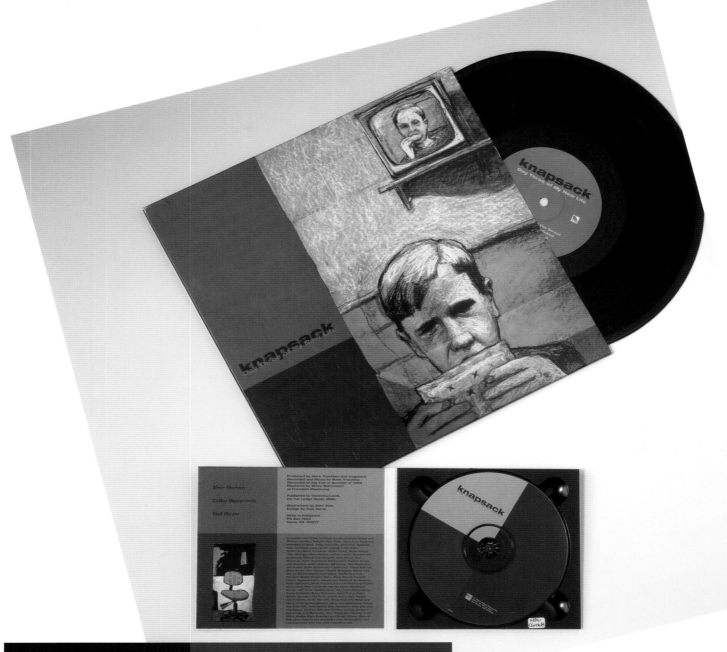

Brushy illustrations by Allen Yost and solid blocks of subdued color create a slight tension that quietly animates Gerst's designs for Knapsack's *Day Three of My New Life* album and CD covers (Alias Records) and related promotional items (a sticker and a calendar).

GLOBAL DOGHOUSE

PRINCIPALS: Barbara George, Stephen Perani
FOUNDED: 1993
NUMBER OF EMPLOYEES: 16

3000 West Olympic Boulevard
Building 2, Suite 1509
Santa Monica CA 90404
TEL (310) 315-4808
FAX (310) 315-4804

Nowadays, promoting movies can appear to be as big a production as the making of a film itself, and advertising is frequently a factor that helps deliver a blockbuster or a bomb. Within an ad campaign, posters or *one-sheets*, as they are called in the entertainment industry, become quickly recognizable icons of the films they promote. Their mission: to sum up and convey, in the context of a few seconds' glance, the character, theme, emotion, and uniqueness of the films they represent. To this task, Barbara George and Stephen Perani of Global Doghouse bring the talents of a design studio that has distinguished itself for its inventive handling of a now-generic form with its own well-established graphic-design conventions. Global Doghouse is one of about a dozen firms in a cottage industry that serves the movie studios' huge marketing operations. Its signature look has been described as "quirky" or "offbeat," as in its poster for Hollywood's most recent adaptation of *Romeo and Juliet*, in which a kind of iron cross serves as the *and* in the title, and in its stark, high-contrast designs for *Zero Effect* and *Two Girls and a Guy*. George and Perani have also been known to leave stars' images out of their posters completely; the effect can be titillating and dramatic, as in their design for *Batman Returns*, which showed only the superhero's famous black cowl against a plain white background. Its only text was the word *return*. In reading a film script, George and Perani say they "look for its essence." As designers, Perani notes, they then strive to "convey its message in a concept...in an artistic way."

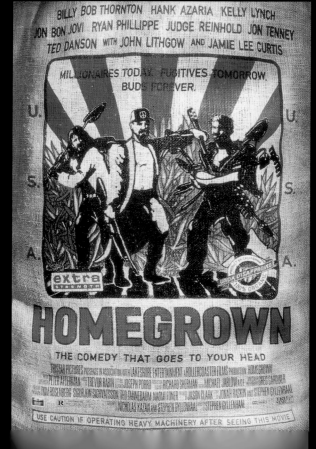

Taking their cue from the film's title and its story's setting, the Global Doghouse designers used a burlap crop sack as the background for this poster for *Homegrown*, a technique that lends the piece added visual texture.
ART DIRECTOR: Mary Evelyn McGough
CREATIVE DIRECTOR: Stephen Perani
ILLUSTRATOR: Dean McCreary
PHOTOGRAPHY: Ron Derhacopian

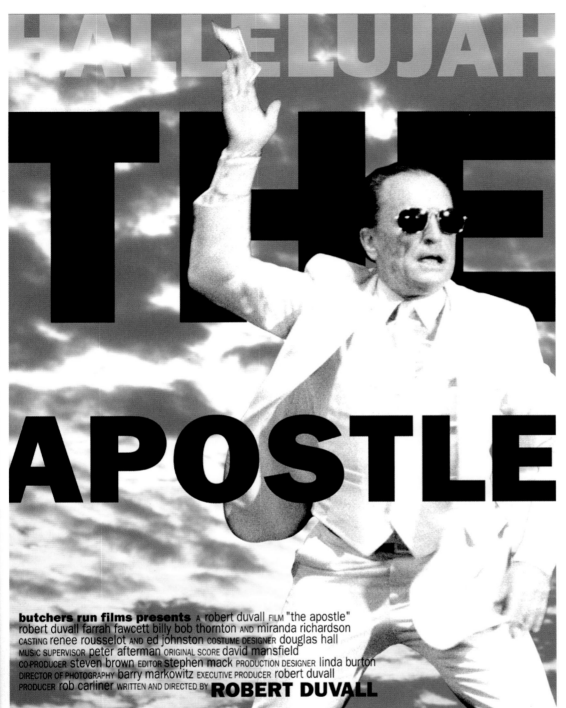

butchers run films presents A robert duvall FILM "the apostle"
robert duvall farrah fawcett billy bob thornton AND miranda richardson
CASTING renee rousselot AND ed johnston COSTUME DESIGNER douglas hall
MUSIC SUPERVISOR peter afterman ORIGINAL SCORE david mansfield
CO-PRODUCER steven brown EDITOR stephen mack PRODUCTION DESIGNER linda burton
DIRECTOR OF PHOTOGRAPHY barry markowitz EXECUTIVE PRODUCER robert duvall
PRODUCER rob carliner WRITTEN AND DIRECTED BY **ROBERT DUVALL**

Global Doghouse's signature look
has been described as "quirky"
or "offbeat," as in its poster for
Hollywood's most recent adaptation of
Romeo and Juliet, in which a
kind of iron cross serves as the
and in the title, and in its design
for *The Apostle*, in which the film's
title is set in huge display type,
evoking the thunderous energy of
its main character.

ART DIRECTORS: Chris Tsirgiotis, *Romeo
and Juliet*; Mary Evelyn McGough,
The Apostle

CREATIVE DIRECTOR: Stephen Perani

PHOTOGRAPHY: Van Redin, *The Apostle*

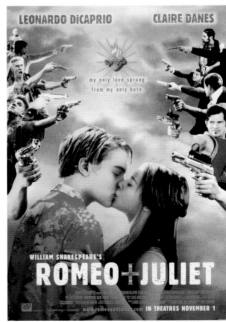

Silhouetted faces of the familiar main characters from the *Star Wars* movies are key elements in Global Doghouse's series of posters for the popular film trilogy's special-edition re-release.

ART DIRECTORS: John Alvin, *Star Wars*; Drew Struzan, *The Empire Strikes Back* and *Return of the Jedi*

CREATIVE DIRECTOR: Stephen Perani

ILLUSTRATOR: Drew Struzan

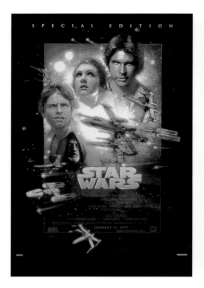
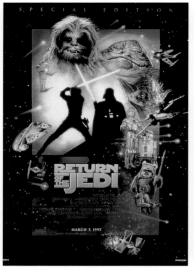
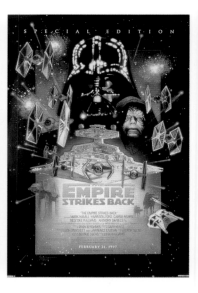

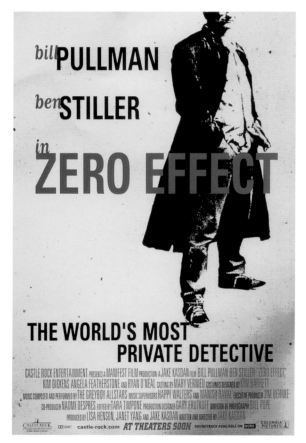

Each movie poster must work hard to stand out amidst the clutter of the advertising-soaked visual environment. With this in mind, Global Doghouse's high-contrast designs for *Zero Effect* and *Two Girls and a Guy* are stark and striking.

ART DIRECTOR: Mary Evelyn McGough

CREATIVE DIRECTOR: Stephen Perani

PHOTOGRAPHY: Robert Erdmann, *Two Girls and a Guy*; E. J. Camp, *Zero Effect*

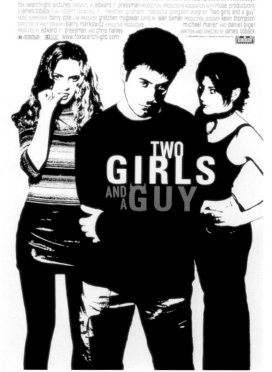

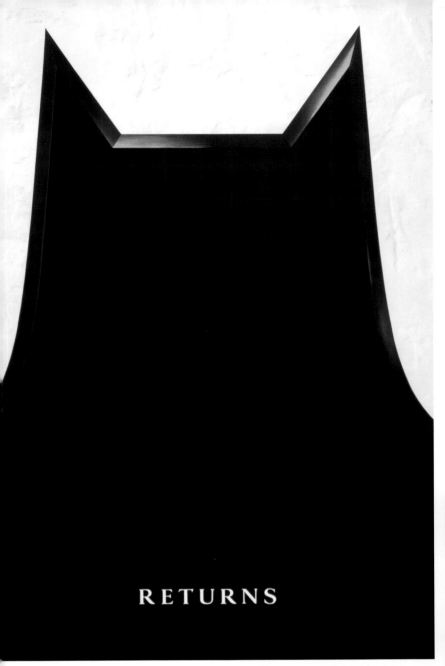

RETURNS

Some Global Doghouse-designed posters create a dramatic visual allure by using very few graphic elements to evoke the mood or theme of a film. They may even leave out images of a film's famous stars. The effect can be eye-catching and compelling, as in these posters for *Batman Returns* and *The Relic*.

CREATIVE DIRECTOR: Stephen Perani
ART DIRECTORS: Massy Rafani, Randi Braun, Stephen Perani, *Batman Returns, logo*; Randi Braun, *Batman Returns, cowl*; Stephen Perani, *The Relic*
DESIGNER: Kevin Bachman, *The Relic*
PHOTOGRAPHY: Alex Fernbach, *Batman Returns, logo*; Matt Mahurin, *The Relic*

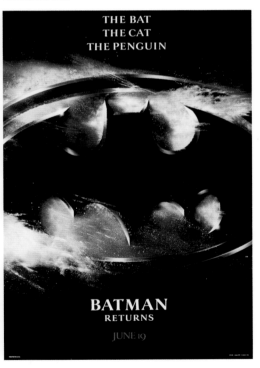

THE BAT
THE CAT
THE PENGUIN

BATMAN
RETURNS

JUNE 19

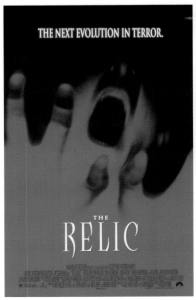

THE NEXT EVOLUTION IN TERROR.

THE
RELIC

PRINCIPAL: April Greiman
FOUNDED: 1977
NUMBER OF EMPLOYEES: 5

620 Moulton Avenue
Suite 211
Los Angeles CA 90031
TEL (213) 227-1222
FAX (213) 227-8651

GREIMANSKI LABS

"Welcome to Greimanski Labs—the purely scientific approach!" proclaims the first message a visitor to April Greiman's Web site encounters (at www.aprilgreiman.com). Then, as Greiman's smiling face and shaved head appear and fill the computer-monitor screen, a flickering follow-up command-cum-credo advises: "No thinking. If thinking, think nothing." If those two pronouncements at first seem contradictory, in part, they are. But they also reflect two poles of creativity, two distinct perspectives concerning creative thought and action that have both found strong—and influential—expression in Greiman's substantial body of work. Regarded as a doyenne of the contemporary Los Angeles design scene, Greiman was one of the first, in "computer time," back in the now long-distant eighties, to embrace the desktop machine and envision its potential as a multifaceted power tool for designers. Beyond classically modern problem-solving, her interest in design as a visual language that speaks not only through printed materials but also through the built environment is mirrored in her collaborations with architects and in her graphics for schools, organizations or exhibitions involved with urbanism or architecture. Design's role as a giver and articulator of structure appears prominent in Greiman's work, from such projects as her identity scheme and original collection of dinnerware for a restaurant in Taiwan to her *Building in L.A.* brochure-and-map set for the Southern California Institute of Architecture (SCI-ARC).

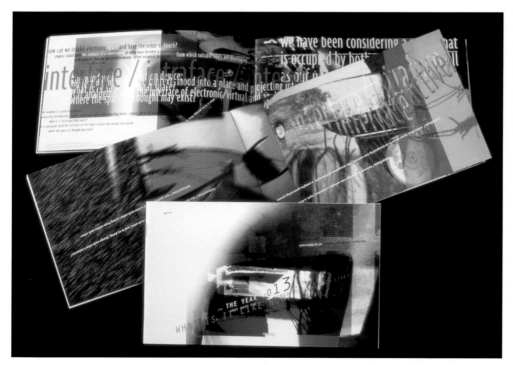

Overlapping headlines, layers of information, and dynamic visual rhythms evoke a sense of the non-formulaic, creative thinking associated with the most innovative art and design schools like SCI-ARC, for which Greiman created this colorful promotional booklet.
DESIGNER: April Greiman

The luminosity of the motion-graphics Web site sequence that Greiman created for LuxCore—a quality that is especially appropriate for a company with such a name—is captured on the corresponding stationery that is part of its corporate-identity program.

DESIGNER: April Greiman
COMPUTER PUSH ANIMATION: April Greiman, Neal Izumi

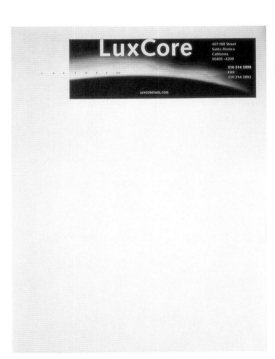

A teaser-introduction sheet printed on vellum and a wrap-around band help unify a group of inserts that describe various aspects of SCI-ARC's program.
DESIGNER: April Greiman

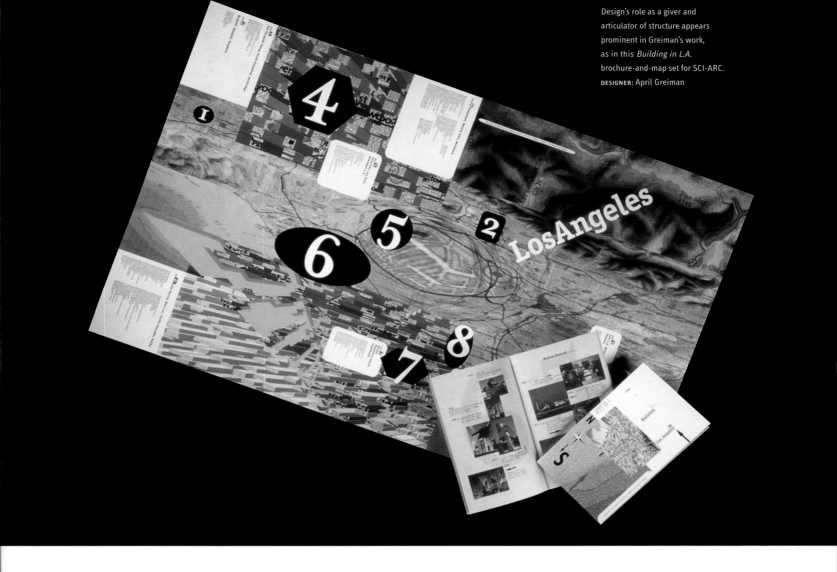

Design's role as a giver and articulator of structure appears prominent in Greiman's work, as in this *Building in L.A.* brochure-and-map set for SCI-ARC.

DESIGNER: April Greiman

Neither ideas nor graphic elements in a layout are tied down, regimented, or bound by conventional organizational rules in April Greiman's work, as the look of her studio's own stationery attests.

DESIGNER: April Greiman

PRINCIPAL: Larimie Garcia
FOUNDED: 1996
NUMBER OF EMPLOYEES: 2

8640 Sunny Slope
San Gabriel CA 91775
TEL (626) 292-6928
FAX (626) 292-6928

GIG DESIGN

Los Angeles is a major center of the music business, which has long been inextricably linked to the youth culture, whose attitudes and aspirations its products have powerfully reflected—and nurtured. Ever since the advent of the long-playing album, record-cover art and related promotional items—posters, stickers, point-of-purchase displays—have become vital pop-music marketing tools. They have also provided highly visible opportunities for graphic designers to help shape the looks of the popular culture and to reach international audiences in the millions. In this tradition, Gig Design's Larimie Garcia began his career at Warner Bros. Records and A & M Records; he founded his own studio in 1996 and has come to specialize in music-related print and Web site design. More recently, he has begun creating motion graphics. "I love detail in design," says Garcia, who began lettering as a teenager. "I try to do what I think needs to be done, not what I think people should see; I want to convey an idea or feeling more than anything." In an era of corporation-dominated entertainment products, Garcia's designs function as effective visual branding devices for the performers or creative enterprises that they identify and describe. Garcia's clients have included Capitol Records, Geffen Records, Maverick Records, Innovation Snowboards, and FreshJive, a clothing company.

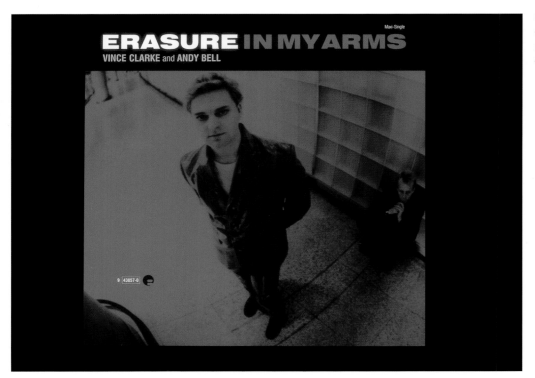

Garcia's CD maxi-single for Erasure, on Maverick Records, evokes the plain looks of fifties-era classic jazz and early-sixties pop album covers.

Garcia designed Viciosa, a typeface with emphatic serifs, and this black-and-white poster to promote it.

The well-known AIDS ribbon strides along in this poster with a strong visual pun for an AIDS Walk.

This logo was created for an adult-entertainment store.

Two familiar symbols, Switzerland's national flag-shield and Jesus Christ's crown of thorns, combine to make a third in Garcia's logo for a band called Swiss Jesus.

The logo for a Black Crowes CD package (the album *Three Snakes and One Charm*) is a swirling, 45 r.p.m. record adapter, a throwback to pop music's pre-digital, vinyl era.

Garcia's CD cover for a promotional single by a band called Lush intentionally recalls the loud looks and screaming headlines of supermarket tabloids.

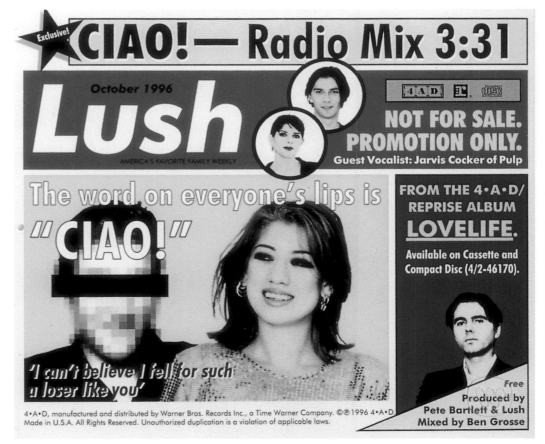

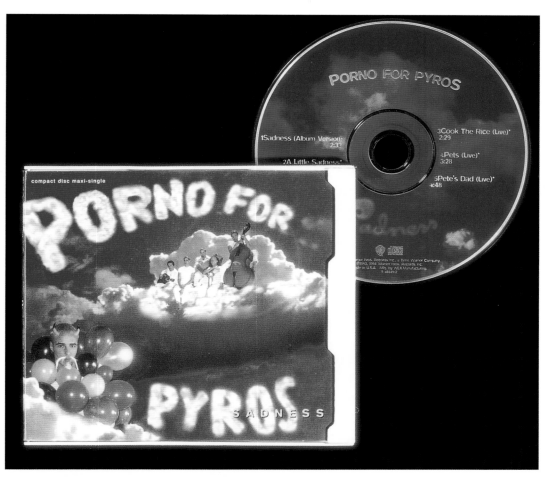

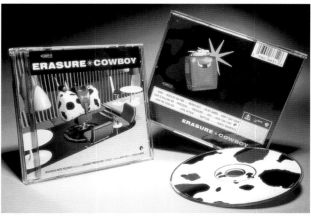

A recording's package is smaller in the CD era, but now, even more than before, the label has become an indispensable platform for graphic design expression, as in this Erasure CD, whose label echoes the cowhide motif on the album's cover. On the Porno for Pyros disc, the motif is a cloud.
ART DIRECTORS/DESIGNERS: Kevin Reagan, Larimie Garcia
ART DIRECTOR: Tom Recchion

INNOVATION

A penchant for Gothic flavors appears in the logos and typography for many rock bands and similarly spirited pop products in the era A.D.C.—after David Carson, that is—as in Garcia's logo for Innovation, a snowboard manufacturer.

Gig Design's design for a Janet Jackson greatest-hits compilation gives an organized, documentary feel to a decade's worth of best-selling tunes.
ART DIRECTOR: Jeri Heiden

With its candy-colored pink and turquoise touches, Garcia's handling of K. D. Lang's *Theme from Valley of the Dolls* CD single hints at the song's camp value, which the singer's interpretation acknowledges.

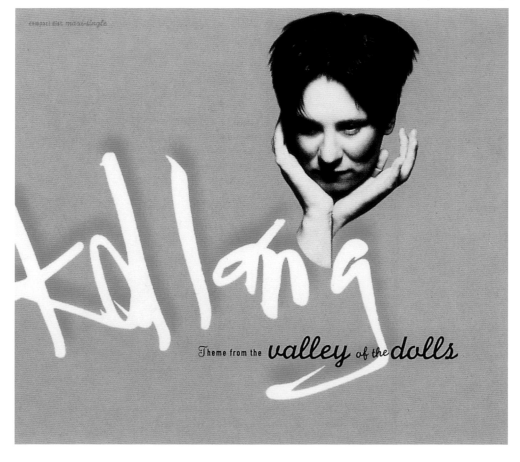

In *Print of Light*, a silk-screened monoprint, Garcia works out ideas involving manipulated type and images.

A brushy logotype captures the spirit of the word it represents.

SHERYL CROW
IF IT MAKES
YOU HAPPY

Letterforms show signs of stylish stress in a type treatment for the title of a Sheryl Crow record.
ART DIRECTOR: Jeri Heiden

PRINCIPAL: Wayne Hunt
FOUNDED: 1978
NUMBER OF EMPLOYEES: 12

25 North Mentor Avenue
Pasadena CA 91106-1709
TEL (626) 793-7847
FAX (626) 793-2549

HUNT DESIGN
ASSOCIATES, INC.

If T. Wayne Hunt's work seamlessly assimilates many of the now-familiar design lessons and values of recent decades—from the related fields of environmental and "super" graphics, for example—then it also incorporates, in its own subtle ways, some of the stylistic touches that have come to characterize a wide range of graphic-design applications today, from the printed page to the directional sign and the trade-show display. In an age of sometimes over-hyped interactivity with computer screens and techno-gadgetry, Hunt's best designs use classic, good-design fundamentals—pronounced, attractive color; clear, uncluttered typography; a sense of order in the designed objects themselves and in the information they convey—to appeal to the eye, grab attention, and deliver a message. A touch of the hand, in the form of the drawings that play a role in the evolution of his designs, may be evident in and become important elements of his work, as in the color-coded signboard of his Granpark signage scheme in Tokyo, or in his International Downtown Association poster. Likewise, Hunt's designs often display a skillful understanding of keep-it-simple, keep-it-clean reductivist principles, abstracting forms (as in his Panda Panda Chinese-restaurant scheme) and maximizing the power of crisp color (as in his palette of primaries in his Kennedy Space Center installation).

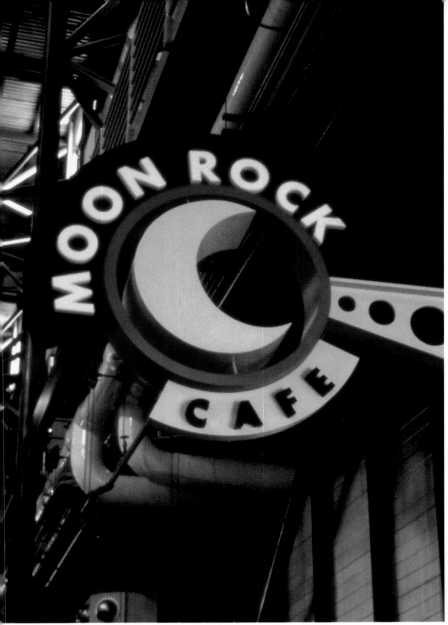

Bold colors and an all-around sense of sturdiness (as in a sign for the Moon Rock Café and the forms of information kiosks) that befit a high-tech, power-evoking subject like rocketships, characterize the installation design for the Apollo *Saturn V* display at the Kennedy Space Center.

DESIGN DIRECTOR: Wayne Hunt

DESIGNERS: Christina Allen, Brian Memmott

PROJECT PRODUCER: BRC Imagination Arts

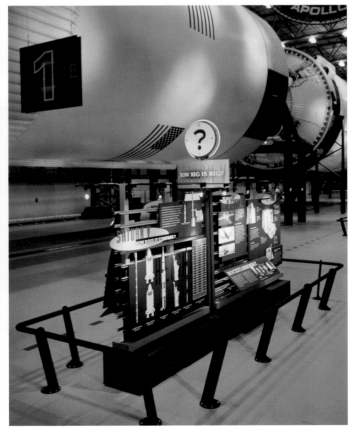

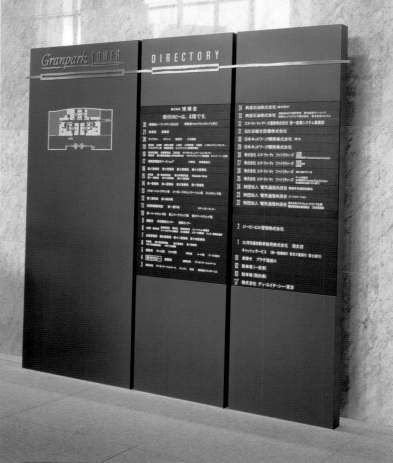

Hunt tweaks the contemporary, international corporate vernacular, in a Japanese context, with illustration integrated into the signage system for the Granpark building complex in Tokyo. A seemingly hand-drawn, faintly jagged line that gives the pristine design scheme a shot of unexpected warmth and tension is echoed in the irregularly cut glass rectangles on the numbered floor-plan signboard.

DESIGN DIRECTOR: Teruko Ohkagawa
DESIGNERS: Wayne Hunt, John Temple, Sharrie Lee

Antique typefaces from the letterpress era recall early nineteenth-century posters in this design for an outdoor, history-themed exhibit in L.A.'s Griffith Park. The mounting of information panels on actual railroad tracks gives the display a sense of novelty and visual texture.

DESIGN DIRECTOR: Wayne Hunt

DESIGNER: Brian Memmott

Brightly colored, playful, freestanding signboards in animal shapes at the Los Angeles Zoo engage youngsters and their adult companions in a discussion of the care and protection of wildlife.

DESIGN DIRECTOR: Wayne Hunt

DESIGNERS: Christina Allen, John Temple, Dinnis Lee

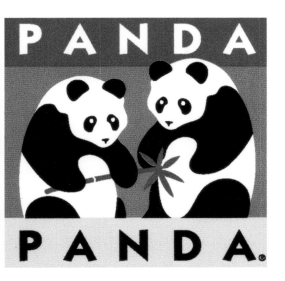

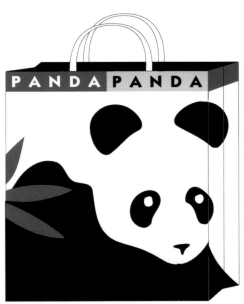

TAKE-OUT BAG

32 OZ. CUP 22 OZ. CUP

A simple palette and the clever use of negative space in the black-and-white panda's form make the applications of this restaurant logo stand out.

DESIGN DIRECTOR: Wayne Hunt
DESIGNERS: Christina Allen, Jennifer Bressler

A signage system for the Los Angeles Metropolitan Transportation Authority is an exercise in classic, color-coded, symbol-driven, late-modern graphic design serving the public in the urban environment.

DESIGN DIRECTOR: Wayne Hunt
DESIGNERS: John Temple, Jennifer Bressler, Brian Memmott

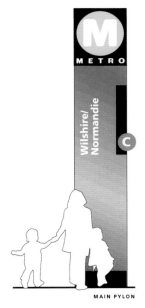

MAIN PYLON

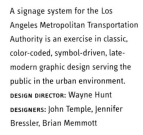

PRINCIPALS: Geoff Kaplan
and collaborators
FOUNDED: 1997
NUMBER OF EMPLOYEES: Varies
depending on nature
of collaborative projects
in progress.

1549 Easterly Terrace
Los Angeles CA 90026
TEL (213) 912-0112
FAX (213) 912-0182

GEOFF KAPLAN

Words and letters cluster, dart, break in unexpected ways, run upside down and backwards, and sometimes seem to want to jump off the page or the screen in Geoff Kaplan's work for print and video. Much of it is energized by compositions that defiantly resist the anchoring force of any traditional, grid-based layout scheme; his type treatments especially avoid such firm moorings, as in his *Intersections and Interstices* booklet for the Cranbrook Academy of Art. Kaplan's typographic audacity can be striking in large proportion, too; even though his postcard announcing an automobile-themed exhibition at the Cranbrook Art Museum is small, its big, bold, irregularly broken headline becomes its central, animating element. And in applying his ideas to the walls and free-standing panels of a trade-show display for Reebok, Kaplan's graphic-design system gives added depth and a sense of movement to the two-dimensional elements in a three-dimensional set-up. Kaplan's work reflects his enthusiastic embrace of the challenges of—and his vision of the inevitable changes to come in—graphic design in the era of the increasingly moving, interactive image, or design-organized information sources. For graphics-makers, he believes, looking ahead, "The understanding of time-based design will now define and direct the professional landscape."

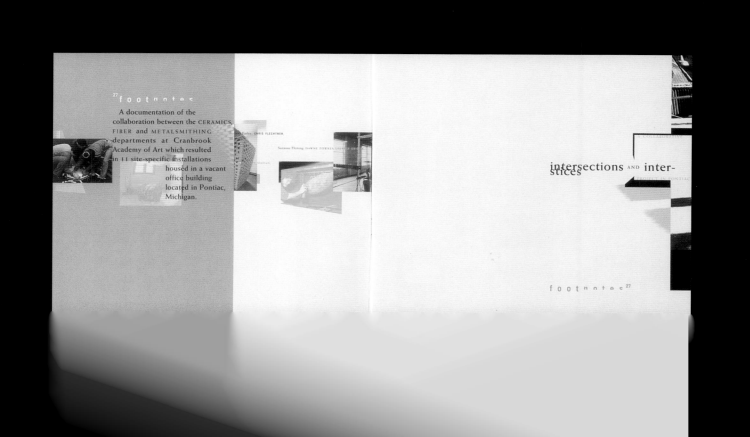

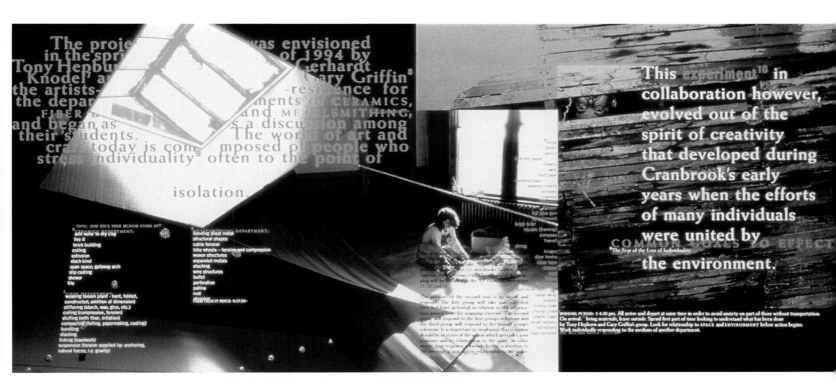

Kaplan's *Intersections and Interstices* booklet for the Cranbrook Academy of Art is energized by layouts that defiantly resist the anchoring force of any traditional, grid-based scheme.

DESIGNERS: Geoff Kaplan, Mikon van Gastel

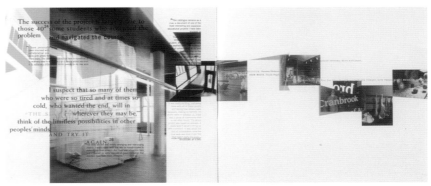

A charmingly schizophrenic Kaplan-designed typeface, Sucker, but features both bold, unadorned strokes and embellished letterforms dripping with dandyish, whip-like serifs.

Sucker, but

A B C D E F G H I

FIVE centuries ago the invention of movable type opened a new epoch in human history by releasing the common people from the thralldom of illiteracy and setting their feet upon the road to self government

Aa Bb Cc Dd Ee Ff Gg Hh Ii Jj Kk Ll Mm Nn Oo Pp Qq Rr Ss Tt Uu Vv Ww Xx Yy Zz

Kaplan used a close-up photo of a picket fence, some familiar typefaces and his own Sucker, but display type in this exhibition-announcement card for the Cranbrook Academy of Art.

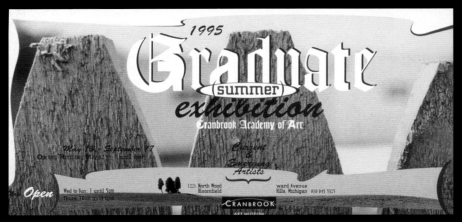

Exit grids, regular text-column
widths, and repeated elements;
enter asymmetry, unexpectedly
broken words, and blown-up,
almost abstracted details in Kaplan's
layouts for a photo-essay book
called *Bordertown*, with a text and
drawings by Barry Gifford and
photographs by David Perry. Here,
Kaplan's consistently inconsistent
page compositions give the flow of
the book an appropriately jarring
feeling that echoes the heightened
sense of life's uncertainties on
society's edges—and at the
crossroads of two cultures—that
the book documents.

DESIGNERS: Geoff Kaplan,
Martin Venezky

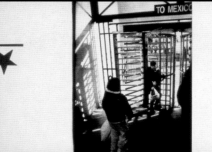

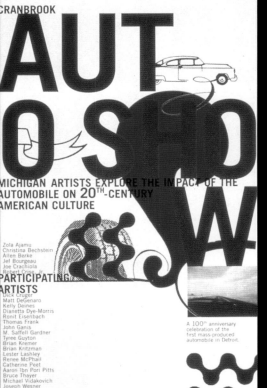

AUTO SHOW

CRANBROOK

MICHIGAN ARTISTS EXPLORE THE IMPACT OF THE
AUTOMOBILE ON 20TH-CENTURY
AMERICAN CULTURE

Zola Ajamu
Christina Bechstein
Allen Berke
Jef Bourgeau
Joe Crachiola
Robert Crise Jr.

PARTICIPATING
ARTISTS

Dick Cruger
Matt DeGenaro
Kelly Deines
Dianetta Dye-Morris
Ronit Eisenbach
Thomas Frank
John Ganis
M. Saffell Gardner
Tyree Guyton
Brian Kremer
Brian Kritzman
Lester Lashley
Renee McPhail
Catherine Peet
Aaron Ibn Pori Pitts
Bruce Thayer
Michael Vidakovich
Joseph Wesner
Marilyn Zimmerman
Gary Zych

A 100th anniversary
celebration of the
first mass-produced
automobile in Detroit.

EXHIBITION @ CRANBROOK ART MUSEUM
JUNE 1 – SEPTEMBER 1 1996
RECEPTION TO MEET THE ARTISTS
SATURDAY JUNE 1 1996
6 – 9PM
LECTURES BY THE ARTISTS ON THURSDAY EVENINGS IN JUNE
CALL 810 645 – 3323 FOR A SCHEDULE

A big, bold, irregularly broken
headline becomes the central,
animating element in this
postcard announcing an
automobile-themed exhibition
at the Cranbrook Art Museum.

Densely overlaid and interwoven
letterforms and visual elements
appear in a video sequence for
J League, a Japanese client.
DESIGNERS: Geoff Kaplan, Kyle Cooper

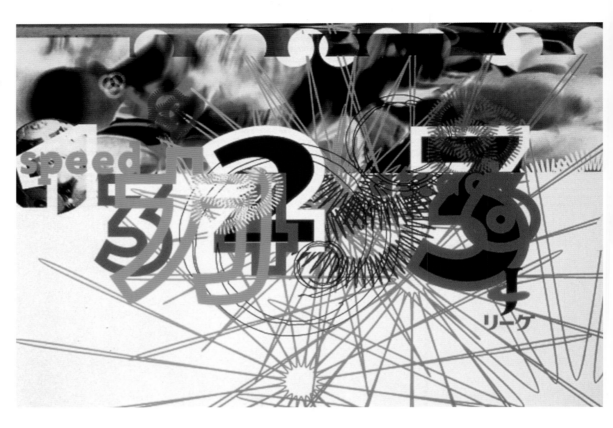

Type takes on a liquid look in a
sequence from a video called *Do
I See? Do I K(no)w?*.

Using design motifs inspired by those found in Reebok's running shoes, Kaplan created graphics, including original typography, for a three-dimensional, trade-show display for the sports-apparel manufacturer.

DESIGNERS: Geoff Kaplan, Martin Venezky, Scott Oliver

PRINCIPAL: Kimberly Baer
FOUNDED: 1981
NUMBER OF EMPLOYEES: 7

620 Hampton Drive
Venice CA 90291
TEL (310) 399-3295
FAX (310) 399-7964

KIMBERLY BAER
DESIGN ASSOCIATES

In the wrong hands, annual reports can become dry documents; however vital they may be to the companies they represent, too many are lifeless and dull. Founded in 1981, Kimberly Baer Design Associates has become known for inventive annual reports, brochures, identity systems, and promotional graphics for corporate and institutional clients, and for non-profit organizations. Its designers inject lively, imaginative elements into these materials and structure them in ways that make them both more attractive and more effective communications tools. Kim Baer notes that, too often, annual reports "try to communicate too many ideas." Instead, she approaches annual reports and other jobs from the standpoint of what she calls "strategic design," working with clients to identify and highlight key message concepts. Fine details are important too, she advises, such as the use of warm colors and photos of people when creating printed pieces for health-care clients (emphasizing the human touch), or bright colors, clean layouts and "modern-feeling" typefaces in designs made for high-tech firms. Baer and her associates often use illustration prominently in their brochure, annual report, and package designs. Their house style skillfully assimilates the contemporary corporate vernacular of the past two decades while gently pushing at its edges.

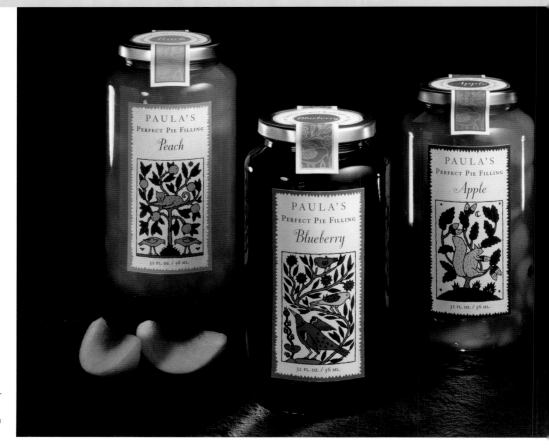

Bright, well-integrated illustrations, like those on these jar labels, reminiscent of woodcuts, are a hallmark of the Baer studio's designs.
ART DIRECTOR: Kim Baer
DESIGNER: Maggie van Oppen
ILLUSTRATOR: Sudi McCollum

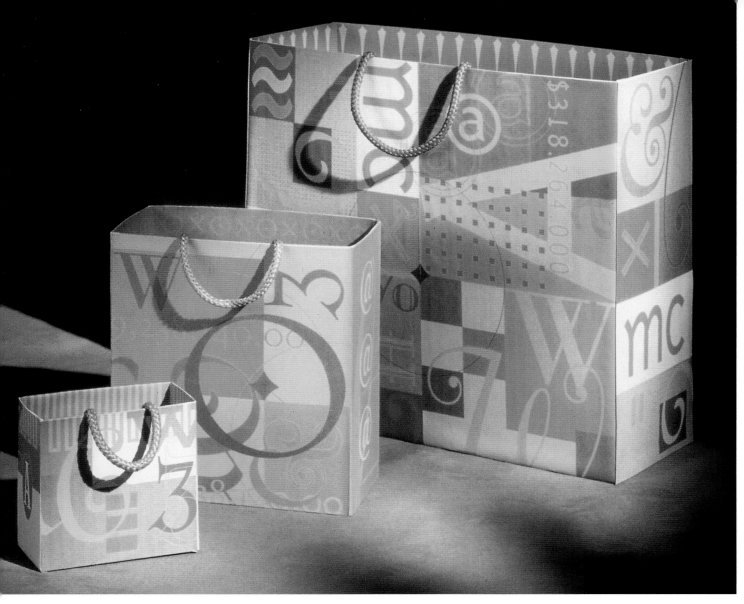

The studio's interpretation of a late-postmodernist style of type treatment expresses itself in an example of the contemporary corporate vernacular in gift bags for Michel & Company.
ART DIRECTOR: Kim Baer
DESIGNER/ILLUSTRATOR: Maggie van Oppen

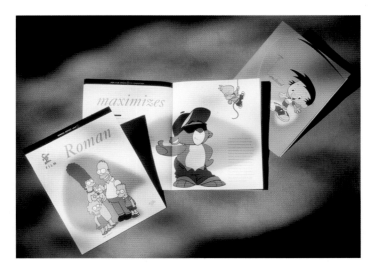

Colorful cartoon illustrations help deliver the nuts-and-bolts financial data in Film Roman's annual report.
ART DIRECTOR: Kim Baer
DESIGNER: Maggie van Oppen

Logos for a cultural center, a record company, and an organization called Tools with Heart, which backs the *Women's Book of Changes*.
ART DIRECTOR: Kim Baer

PUMP
RECORDS

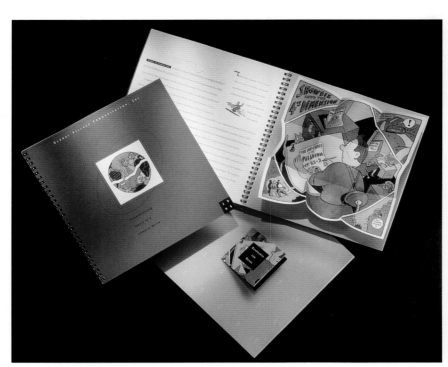

An annual report for Global Village Communication Inc., features comic-style illustrations in an attention-grabbing fold-out.
ART DIRECTOR: Kim Baer
DESIGNER: Barbara Cooper
ILLUSTRATOR: Marc Rosenthal

An annual report for Cylink.
ART DIRECTOR: Kim Baer
DESIGNER: Maggie van Oppen
ILLUSTRATOR: Mick Wiggins

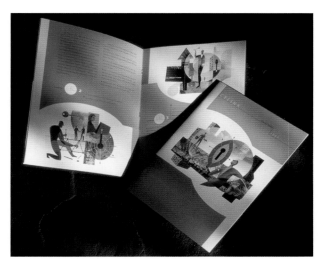

Baer's house style skillfully
assimilates the contemporary
corporate vernacular of the past
two decades while gently pushing
at its edges, as in this brochure for
the Getty Conservation Institute.
ART DIRECTOR: Kim Baer
DESIGNER: Liz Roberts

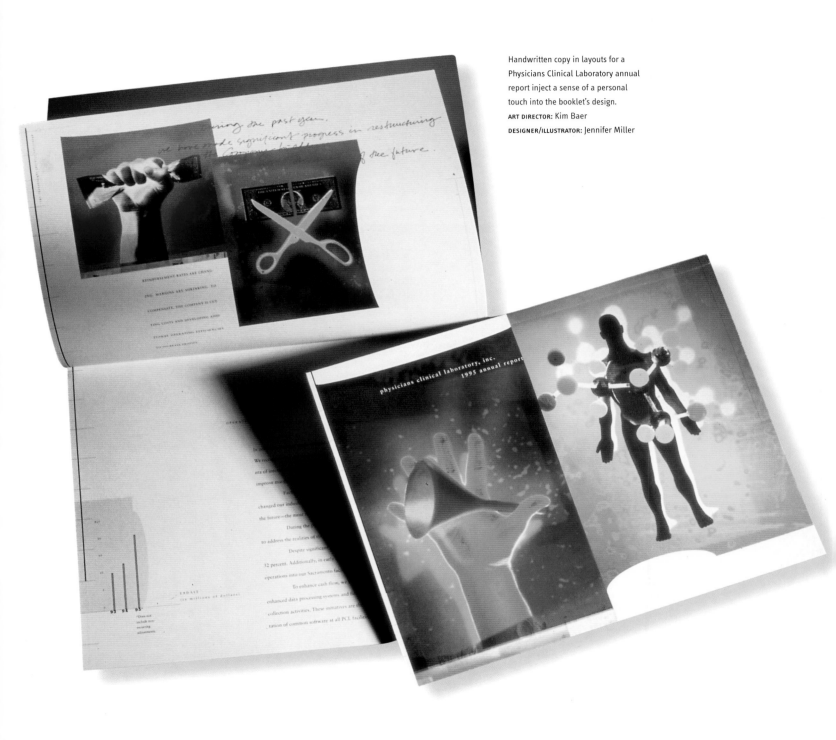

Handwritten copy in layouts for a Physicians Clinical Laboratory annual report inject a sense of a personal touch into the booklet's design.

ART DIRECTOR: Kim Baer

DESIGNER/ILLUSTRATOR: Jennifer Miller

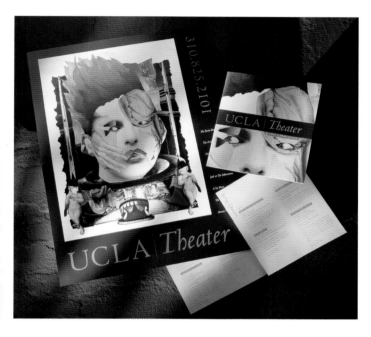

An edgy collage illustration and stately typeface combine in a poster for the UCLA Theater Department's program of plays.
ART DIRECTOR: Kim Baer
DESIGNER: Maggie van Oppen

The studio crafted a high-tech look for GranCare's annual report.
ART DIRECTOR: Kim Baer
DESIGNER: Barbara Cooper
PHOTOGRAPHY: Oe Ueda, Dana Gluckstein

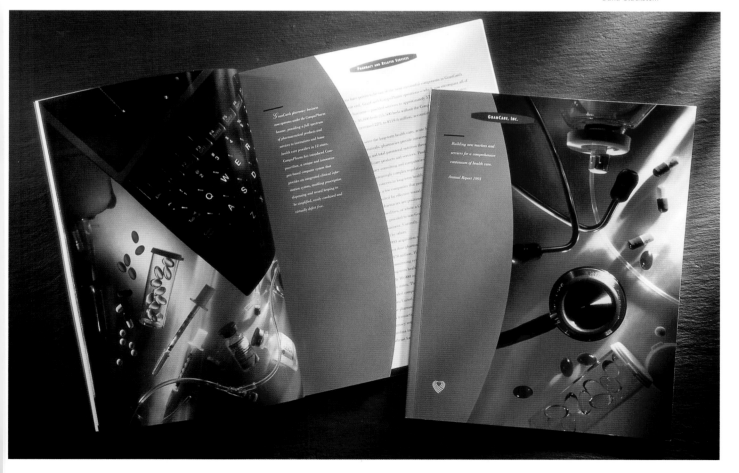

PRINCIPALS: Judith Lausten, Renée Cossutta
FOUNDED: 1984
NUMBER OF EMPLOYEES: 2

1724 Redcliff Street
Los Angeles CA 90026
TEL (213) 663-3715
FAX (213) 663-0725

LAUSTEN + COSSUTTA
DESIGN

Judith Lausten studied painting and art history before earning her master's degree in graphic design from the California Institute of the Arts. A native Easterner, Renée Cossutta moved to Los Angeles after studying at Smith College and earning her master's degree in graphic design from Yale University. Before opening a studio with Cossutta in 1984, Lausten worked as a senior designer of publications and collateral materials for her undergraduate alma mater. She also served as a design consultant in the development and implementation of a graphic-design program and supporting style manual for Kaiser Permanente, the giant health-care insurance company. Before teaming up with Lausten, Cossutta had worked in New York for such high-profile art-book publishers as George Braziller and the Metropolitan Museum of Art. After moving to Los Angeles, she worked on the environmental graphics and informational publications for the city's 1984 Summer Olympics. Considering their backgrounds, it's probably no surprise that numerous art books and exhibition catalogs have distinguished Lausten and Cossutta's combined portfolio. For pleasure, they like photographing vernacular signage and the industrial landscape, and collecting great design finds from hardware or grocery stores, and this broad interest in design is reflected in their work for such clients as the Southern California Institute of Architecture, the Los Angeles Center for Photographic Studies, and other cultural organizations.

A text block that curves on one side creates a kind of scrim of type that gives depth to this poster for a lecture series at the Southern California Institute of Architecture. It also softens the hard planes shown in the architectural photograph reproduced on the poster.
DESIGNERS: Judith Lausten, Renée Cossutta

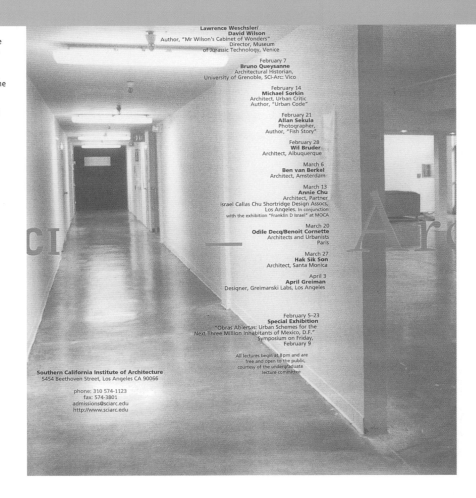

Lausten and Cossutta's book-design
contribution was integral to, not a
subordinate aspect of, the making
of a large A.R.T. Press volume about
the work of painter Chuck Close,
in which full-page, large-scale photo
portraits echoed the artist's famously
detailed canvases.
DESIGNERS: Judith Lausten,
Renée Cossutta

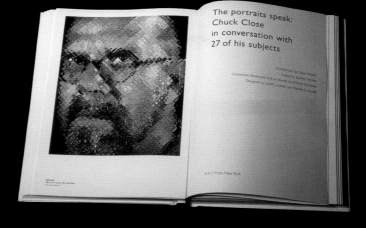

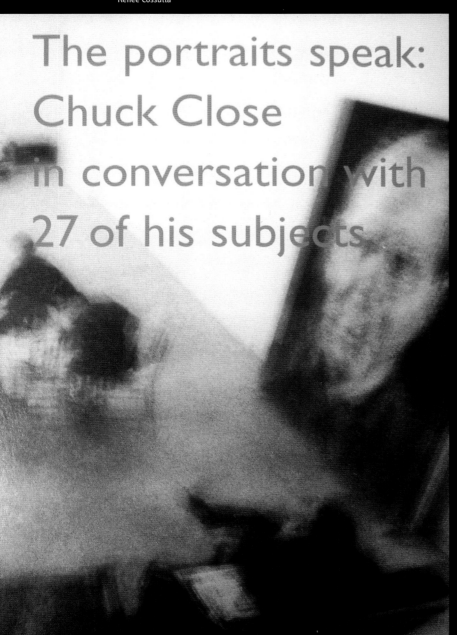

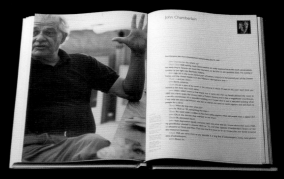

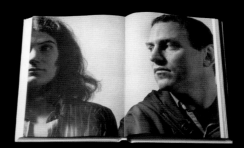

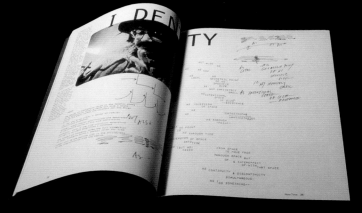

A free-for-all of type treatments, including many set against generous expanses of plain white space, can be found in an issue of a publication called *Now Time* for which Lausten and Cossutta provided art direction. **DESIGNERS:** P. Lyn Middleton, Laurie Haycock, Somi Kim, Barbara Glauber, Chris Vice, Win Utermohlen, Susan Silton, Chris Myers, Nancy Mayer, Judith Lausten

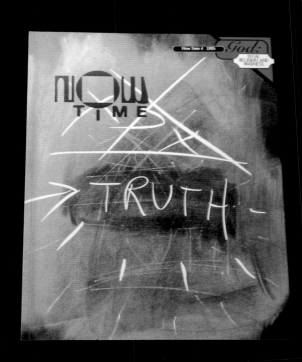

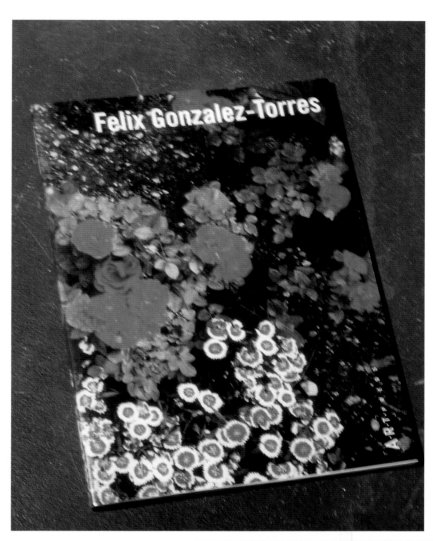

Lausten and Cossutta created this
book about the contemporary
urban artist Felix Gonzalez-Torres
for A.R.T. Press in New York, under
whose auspices they received a
National Endowment for the Arts
design grant in 1993.
DESIGNERS: Judith Lausten,
Renée Cossutta

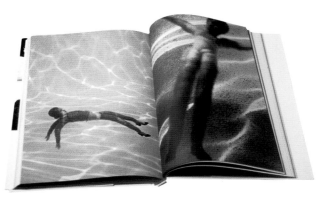

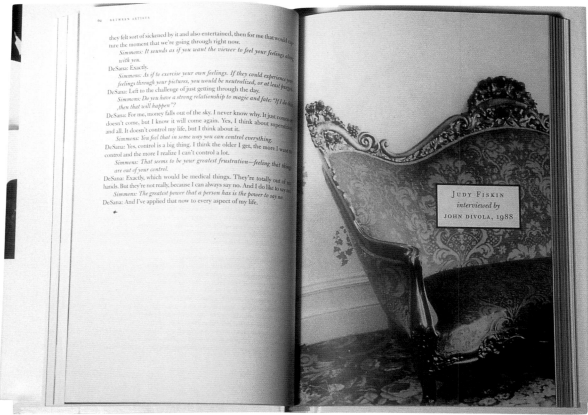

they felt sort of sickened by it and also entertained, then for me that would capture the moment that we're going through right now.

Simmons: It sounds as if you want the viewer to feel your feelings along with you.

DeSana: Exactly.

Simmons: As if to exercise your own feelings. If they could experience your feelings through your pictures, you would be neutralized, or at least purged.

DeSana: Left to the challenge of just getting through the day.

Simmons: Do you have a strong relationship to magic and fate: "If I do this, then that will happen"?

DeSana: For me, money falls out of the sky. I never know why. It just comes or doesn't come, but I know it will come again. Yes, I think about superstition and all. It doesn't control my life, but I think about it.

Simmons: You feel that in some way you can control everything.

DeSana: Yes, control is a big thing. I think the older I get, the more I want to control and the more I realize I can't control a lot.

Simmons: That seems to be your greatest frustration—feeling that things are out of your control.

DeSana: Exactly, which would be medical things. They're totally out of my hands. But they're not really, because I can always say no. And I do like to say no.

Simmons: The greatest power that a person has is the power to say no.

DeSana: And I've applied that now to every aspect of my life.

JUDY FISKIN
interviewed by
JOHN DIVOLA, 1988

Lausten and Cossutta's work for A.R.T. Press, a New York-based publisher of lavishly illustrated books about contemporary-art makers, includes a volume on Laurie Simmons and another in which artists interview other artists. **DESIGNERS:** Judith Lausten, Renée Cossutta

This fold-out packet informing
libraries about the availability of
books published by A.R.T. Press
and giving ordering instructions
for its titles is active and engaging
despite a limited color palette.
DESIGNERS: Judith Lausten,
Renée Cossutta

PRINCIPALS: Robert Louey,
Regina Rubino
FOUNDED: 1984
NUMBER OF EMPLOYEES: 7

2525 Main Street
Santa Monica CA 90405
TEL (310) 396-7724
FAX (310) 396-1686

LOUEY/RUBINO
DESIGN GROUP, INC.

Sumptuousness is not a characteristic that is often emphasized or championed in the making of most contemporary design. It is a quality too closely associated with costliness, not to mention extravagance, and it sits somewhat uncomfortably with the stripped-down, less-is-more dictates of classical modernism. But Louey/Rubino Design Group's most memorable work—including its self-promotional booklet for its Indonesian affiliate and its promotional calendars produced in conjunction with various paper-making companies—achieves a perfectly pitched, fine balance between the unabashedly elegant and the thoughtfully functional. Designs like these are rich in visual texture thanks to the use of multi-layered, collage-like illustrations. Production details are distinctive, too, and engage a user-reader actively in experiencing a Louey/Rubino printed piece as an interesting information package. With their specially cut, string-tied flaps or clever inserts—like the luggage tag announcing Marden-Kane, Inc.'s incentive-travel program—these designs perform as much as they inform. "The symbiotic union of language and visual form is what defines communications," notes partner and creative director Robert Louey, who founded the studio in 1984 with Regina Rubino. Louey/Rubino Design Group, Inc. also maintains a New York office and an affiliate sister company in Jakarta, Indonesia.

Everything.
In 1996, Kaufman and Broad made the right moves, at the right time, in the right way. It was also the right time to look at our business from a completely different perspective.

KAUFMAN AND BROAD HOME CORPORATION 1996 Annual Report

What's right with this picture?

Louey/Rubino's annual report for construction giant Kaufman and Broad Home Corp. shakes up the form with its use of fine, speckled, colored papers, bright illustrations, and bold, large section headlines.

ART DIRECTOR/CREATIVE DIRECTOR: Robert Louey

ILLUSTRATOR: Brent Day

PHOTOGRAPHY: Stanley Clime

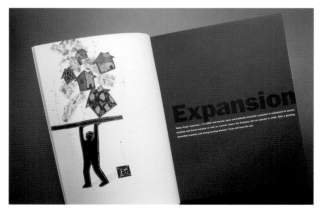

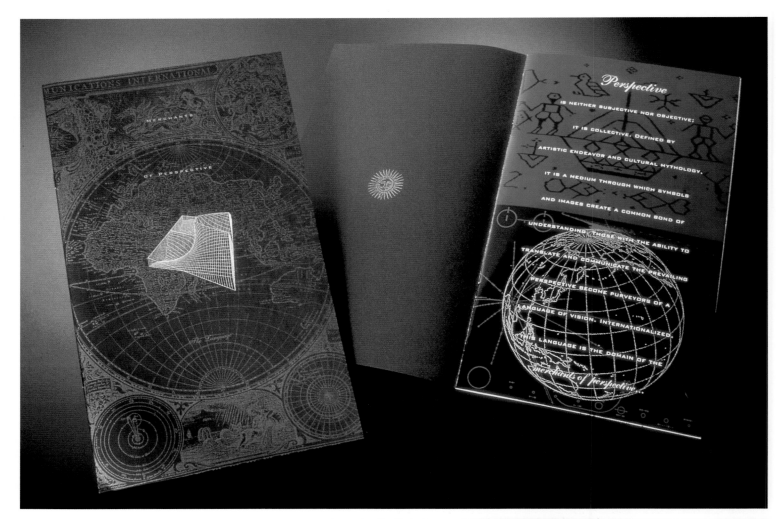

A promotional booklet for the studio's affiliate company based in Indonesia is rich in visual texture and hints at the sophistication and cultural sensitivity that it brings to its design work.

ART DIRECTOR/CREATIVE DIRECTOR:
Robert Louey

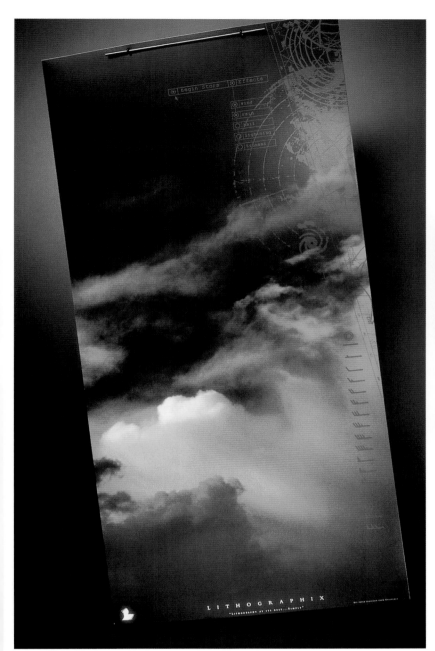

An explosion of vibrantly colored,
ornate patterns shows off the
assets of the paper on which
this promotional calendar for
Lithographix is printed.
ART DIRECTOR/CREATIVE DIRECTOR:
Robert Louey

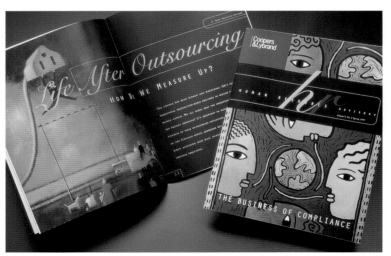

Louey/Rubino's designs for
Coopers & Lybrand's in-house
human-resources publication puts
a bright face on the bureaucratic,
sometimes stressful aspects of
management-employee relations.
ART DIRECTOR/CREATIVE DIRECTOR:
Robert Louey
DESIGNER: Tammy Kim

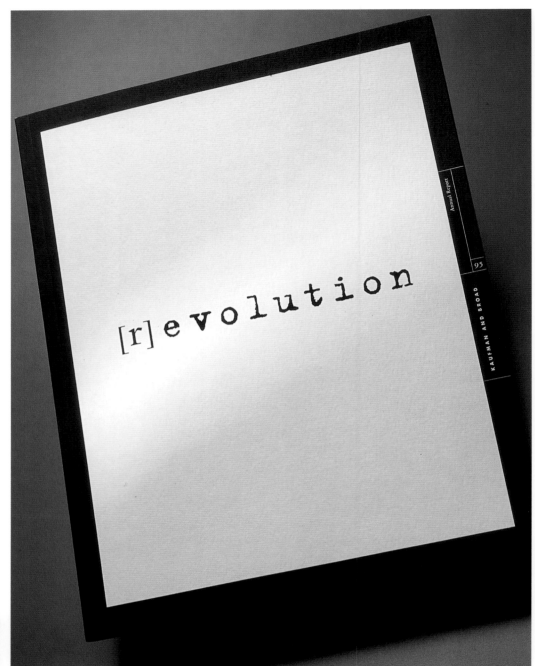

This annual report's cover layout immediately suggests a fact-filled dossier, but its slightly tweaked typewriter typography hints that some provocative design touches are in store inside.

ART DIRECTOR/CREATIVE DIRECTOR:
Robert Louey
PHOTOGRAPHY: Eric Tucker

With its black-cloth covers, and gold, red, and black pages, this 16-page promotional piece announcing the fiftieth anniversary of the Jackie Robinson Foundation is more of a hardbound-book keepsake than a throwaway booklet. Its serious-looking physical qualities lend a sense of gravitas to the institution it commemorates.

ART DIRECTOR/CREATIVE DIRECTOR:
Robert Louey

PHOTOGRAPHER: Terry Heffernan

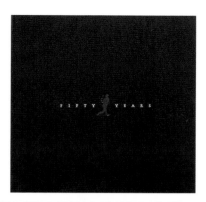

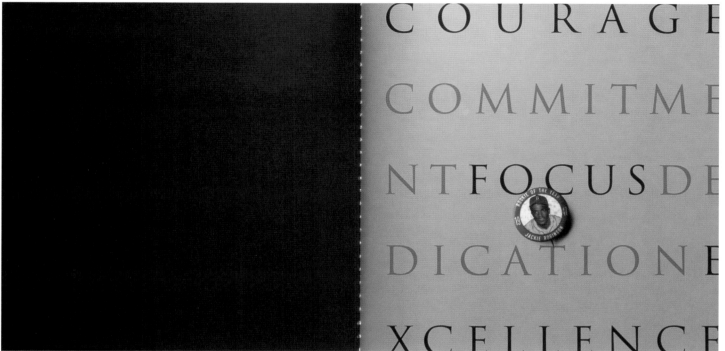

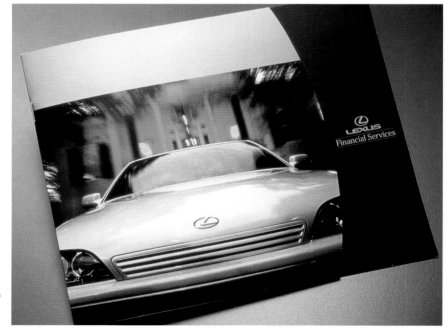

In keeping with the car brand's upscale marketing image, simple, contemporary elegance characterizes Louey/Rubino's booklet for Lexus Financial Services.

PRINCIPALS: Frank Maddocks,
Mary Scott
FOUNDED: 1973
NUMBER OF EMPLOYEES: 30

2011 Pontius Avenue
Los Angeles CA 90025
TEL (310) 477-4227
FAX (310) 479-5767

MADDOCKS & COMPANY

Maddocks & Company, which also maintains a New York office, specializes in using design to shape the looks—and, intentionally and explicitly, the meanings and values—of a wide range of goods, from candy and bath soap to golf clubs and laser-equipped hair-removal systems. More than anything, Maddocks & Company's métier is branding, in all its late twentieth-century complexity. Whether starting from scratch to concoct a new brand, as the studio did by developing a unique identity and package architecture for Gelson's Markets' in-house line of food items, or beginning with already well-established subject matter like the Warner Bros. cartoon characters and fashioning a line of children's hair-care products around them, in its designs, Maddocks & Company routinely demonstrates a sophisticated understanding of both client goals and target audiences. This large firm's design-aesthetics repertoire ranges from the warmly retro looks of its wrappers and point-of-purchase displays for Astor Chocolate to the user-friendly, clinical minimalism of its delicately toned packages for Murad cosmetics. Whatever the marketing expertise behind them, many Maddocks & Company packages and printed pieces exude a sensuous aura.

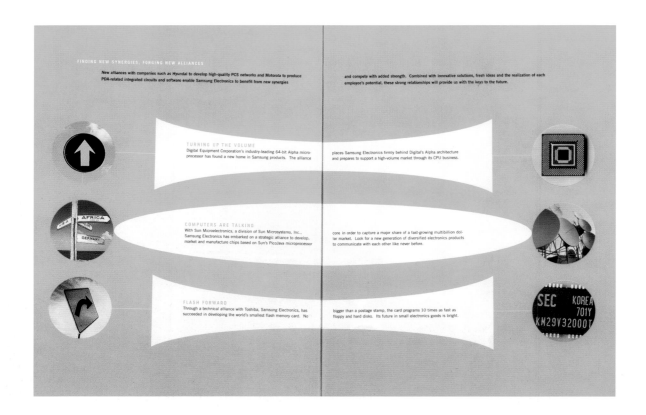

1997: Increase overall efficiency by 20%. Work force: Expand from 13,000 overseas employees to 50,000 by the year 2000. Facilities: Expand from 22 plants in 15 countries to 60 plants in 21 countries. Production: Boost overall overseas production from 9% to 20%, and production of five main products from 28% to 70%. Sales: Grow overseas sales from US$14 billion to US$40 billion. Organization: Integrate management structure, end segmentation. Build a global network of local decision makers. Culture: Reshape from top to bottom, starting with a renewed focus on quality over quantity and a deepening sense of humanism. Task: Combine our efforts for a streamlined journey into a strong, competitive future. Commitment: Invest in research and development to benefit a global community. Goals: Adhere to a five-point action plan. First point: Pricing. Reform methods and price management and compare best-selling models by category. Support each operation for maximum potential in all markets. Second point: Communications. Build two-way relationships between headquarters and regional offices. Third point: Overseas management. Increase support to enable overseas operations to become free-standing, responsive and flexible. Fourth point: Marketing. Diversify strategies as worldwide demand continues to grow, to increase exports of value-added products and home appliances and to grow our international telecommunications business. Fifth point: Products. Increase focus on telecommunications and microprocessors and other non-memory products. Home: The place where connecting with a global community matters most. Focus: Customer needs now and for the future. Approach: Local engineers designing products to fit local tastes and demands. Brand: Synonymous with flexibility and responsive service. Opportunity: Build on our reputation to encompass all ventures at all levels. Key: Synergy.

See you at the epicenter of the digital revolution.

22 23

A fifties-retro, atomic age look, with a muted, pastel palette, unifies an annual report for electronics maker Samsung.

SAMSUNG ELECTRONICS *1996*

Global VISION in the 21st Century

POTENTIAL

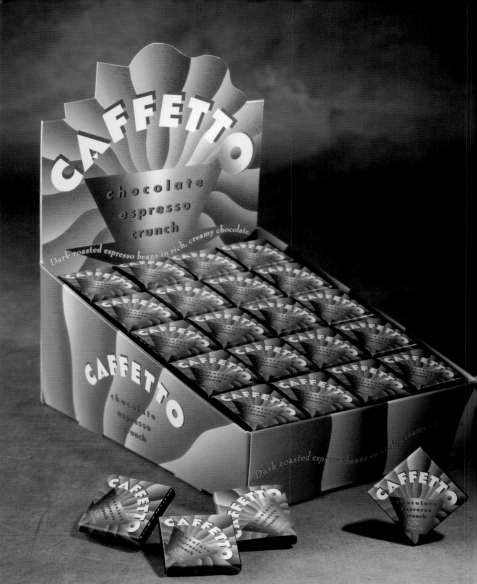

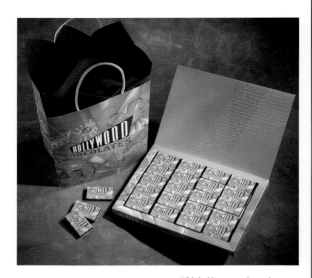

With bold typography and a
retro air, logos, wrappers, and
point-of-purchase displays for
Astor Chocolate's Hollywood
Chocolates and Caffetto specialty
brands evoke the golden age of
the poster and of the popular
movie house.

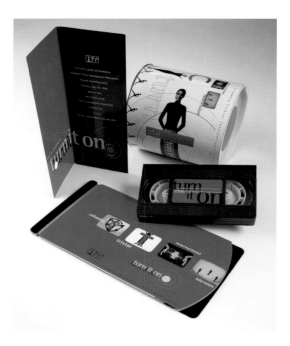

Deep scarlet red grabs attention and
repeated, overlapping type animates
promotional material for a Columbia
Tristar television campaign.

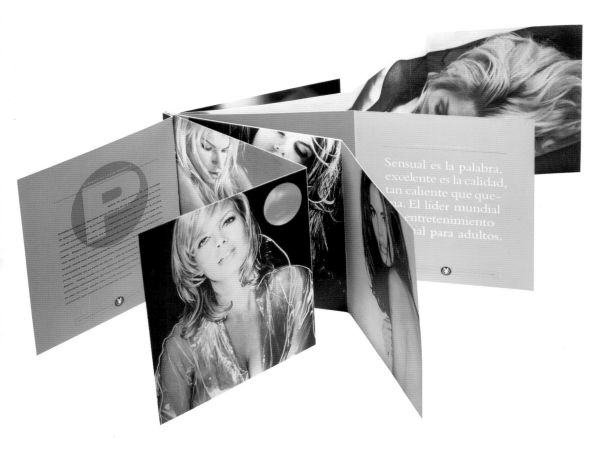

Fold-out pages (reminiscent of its parent publication's glossy centerfolds) and a high contrast between crisp, black-and-white photos and warm, bright, solid colors help give a corporate look to the skin trade in promotional items for Miami-based Playboy TV Latin America.

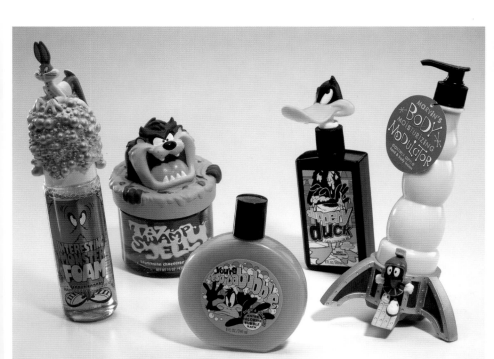

The package is the product, and the cartoon character is the package, in these jars and bottles of children's bath and hair-care items created for Warner Bros.' retail stores.

In contrast to the studio's packages for girlcare's brightly colored shampoo and hair gel, its Murad cosmetics scheme employs user-friendly, clinical minimalism to suggest these products' cleanliness and purity. In girlcare's logo, unevenly weighted, sans-serif type with perky embellishments—spirals or asterisks in the hollows of round letterforms—aim to catch the eyes of young female consumers.

Logos for girlcare hair-care products, Tegra golf supplies, and the La Brea Bakery.

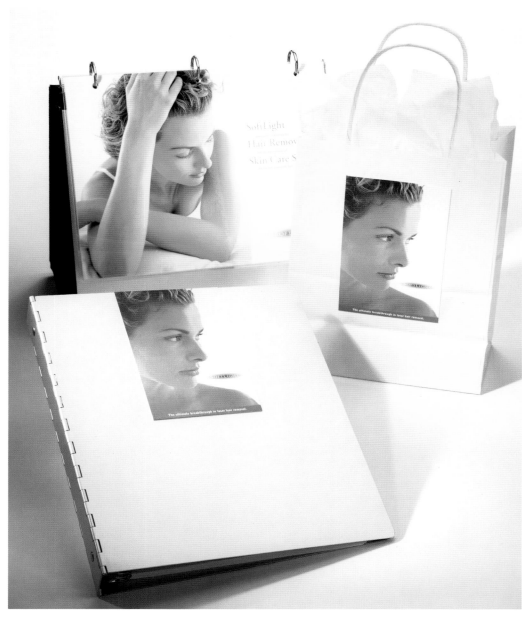

Stark white packaging and printed pieces, delicately adorned with type in light-gray tones, hints at the medicinal-curative in coordinated schemes for SoftLight's cosmetics and hair-removal system.

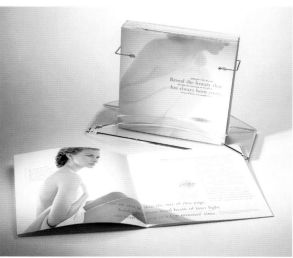

PRINCIPAL: Margo Chase
FOUNDED: 1986
NUMBER OF EMPLOYEES: 6

2255 Bancroft Avenue
Los Angeles CA 90039
TEL (213) 668-1055
FAX (213) 668-2470

MARGO CHASE DESIGN

An instinctive understanding of the gothic—as a mood, a visual style, an aesthetic point of view—distinguishes the look of many of Margo Chase's projects for a range of clients, from rock-music acts to snowboard manufacturers. Her signature style, rooted in a fondness for medieval architecture and illuminated manuscripts, has flourished in entertainment-related applications: movie posters, compact-disc packaging, and logos. Her own Gravy Fonts division distributes Chase-designed display typefaces, such as Portcullis and Envision, with their typically elongated, vine-like serifs. Another, called Kruella, "was inspired by too many comic books and late-night horror movies," Chase muses. Some of this studio's logotypes and multi-layered, type-dense images for print or motion-graphics projects (like an opening-title sequence for the ESPN sports channel's boxing show) can actually be a bit hard to read at first, until a viewer adjusts to and deciphers their rich textures and details. This is graphic design as scene-setter, establishing the context of its usage as much as it reflects it. With this in mind, it's no accident that Chase and her collaborators savor opportunities to work with clients who appreciate unusual design elements intelligently employed. Other times, Chase observes, "Some things are so lame that you can't possibly make them cool and you have to turn them down."

GO FRY AN egg

MAKE NO BONES ABOUT IT

In this joint promotional project for Margo Chase Design and Westland Graphics, a printing company, the studio created a series of cards featuring familiar clichés as a vehicle for experiments with three-dimensional type forms. Some employ strong visual puns, like the Go-fry-an-egg card.

ART DIRECTOR/CREATIVE DIRECTOR/ ILLUSTRATOR: Margo Chase

Chase's multi-layered, type-dense images for print or motion-graphics projects are rich in textures and details. These frames come from *Basic Hip*, the studio's self-promotional short film based on Beat-era jargon, and from Billboard Live Television (BLTV) a nightclub's in-house television-network's identity package.

ART DIRECTOR/CREATIVE DIRECTOR:
Margo Chase

CREATIVE DIRECTOR, *BLTV*:
Adam Bleibtreu

DESIGNERS, *BLTV*: Brian Hunt,
Andreas Heck, Dave McClain

Logotypes created by Margo Chase Design help establish the corporate identities of their subjects as much as they reflect them. Many have a solid, heraldic air. Pictured here: logos for Bowhaus, a service bureau; for Copperfield Magic Underground, a chain of theme restaurants partly owned by magician-entertainer David Copperfield; for Kama Sutra, a line of bath and beauty products; and for Orbit Lounge, a nightclub at the Hard Rock Hotel and Casino in Las Vegas.

ART DIRECTOR/CREATIVE DIRECTOR:
Margo Chase

CREATIVE DIRECTOR, *ORBIT LOUNGE*:
Warwick Stone

DESIGNER, *ORBIT LOUNGE*: Brian Hunt

DESIGNERS, *KAMA SUTRA*: Wendy Ferris Emery, Anne Burdick

ILLUSTRATOR, *KAMA SUTRA*:
Jacquelyn Tough

Chase used her own Envision typeface, with its long, hook-like serifs inspired by letterforms in medieval manuscripts, in these album-cover designs for singer Loreena McKennitt.
PHOTOGRAPHY: Anne Cutting

Chase's prototype identity scheme and design for a brand of menthol cigarettes proposed by Philip Morris brings multi-layered visual texture to a familiar small-package format.
ART DIRECTORS: Munier Sharrieff, Warren Lam/Leo Burnett U.S.A
CREATIVE DIRECTOR: Margo Chase
DESIGNERS: Margo Chase, Wendy Ferris Emery

PRINCIPAL: Anne Burdick
FOUNDED: 1996
NUMBER OF EMPLOYEES: 2

3129 Glendale Boulevard
Los Angeles CA 90039
TEL (213) 666-7356
FAX (213) 666-7459

THE OFFICES
OF ANNE BURDICK

Like certain other designers with whom she shares an aesthetic-intellectual dialog, such as Michael Worthington, Denise Gonzales Crisp, and Geoff Kaplan, Anne Burdick is known as much for her writing and theorizing about design, and as a design educator, as she is for the work that has emerged from her studio for such clients as the Whitney Museum of American Art, Capitol-EMI Records, and the Getty Research Institute for the History of Art and the Humanities. Burdick is interested in the intersection of writing and design, and has elaborated her ideas on this theme both graphically and in words in such publications as *Émigré* and the online *electronic book review*. (On occasion, she has guest-edited and designed them, or has served as their design editor, too.) A graduate of the Art Center College of Design and the California Institute of the Arts, and now a teacher at CalArts, Burdick tugs and pushes at the boundaries of conventional text-and-image compositions. As seen in her announcement for the Getty Research Institute's fellowships, her work strives for an integration of graphic elements whose combined impact shakes up a familiar form—of the poster, brochure, or magazine layout—with the techniques that today's computer-generated design allows, but at an artistic level that, at its best, rises above the usual postmodern posturing to yield genuine works of visual literature that are emblematic of their times.

Burdick chaired the American Center for Design's 20th Annual 100 Show, for which she created this announcement poster.
ART DIRECTOR: Anne Burdick
PHOTOGRAPHY: Susan Burdick

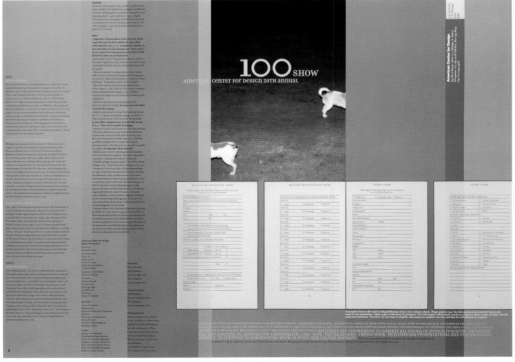

Anne Burdick strives for an integration of graphic elements whose combined impact shakes up familiar forms. An example is this poster announcing fellowships offered by the Getty Research Institute for the History of Art and the Humanities.

ART DIRECTOR: Anne Burdick

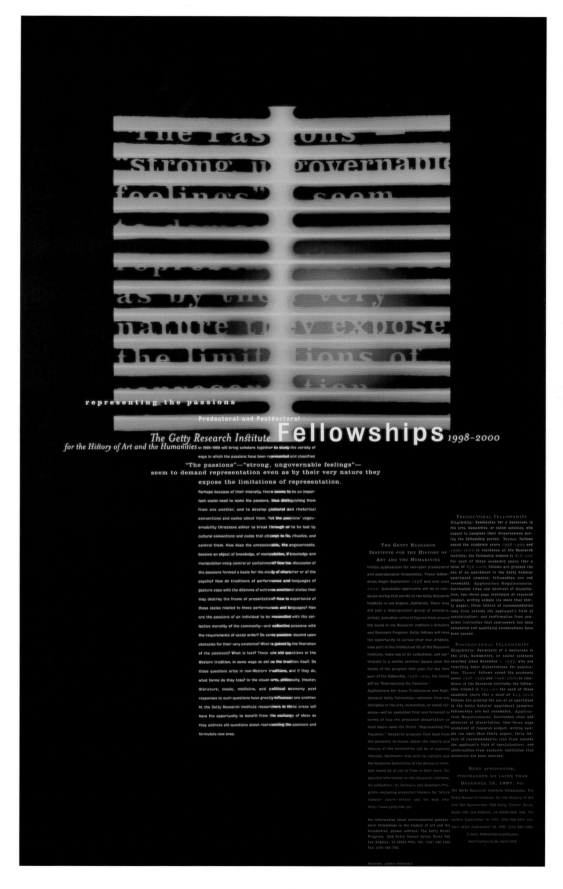

Emigre No. 36 Fall 1995
mouthpiece 2
$7.95

An assignment to guest-edit and design issues 35 and 36 of *Émigré*, which were collectively known by the series title Mouthpiece, gave Burdick an opportunity to explore the intersection of writing and design that is central to her work as a graphic designer and educator. Various photographers and designers also contributed to these issues of the magazine.

ART DIRECTOR: Anne Burdick
CREATIVE DIRECTOR: Rudy Vanderlans

Emigre No. 35 Summer 1995
mouthpiece

In a black-and-white piece for a Ralph Gibson exhibition at New York's Whitney Museum of American Art, seemingly arbitrary hairlines become a regular motif that quietly energizes the brochure's layout.

ART DIRECTOR: Anne Burdick

PHOTOGRAPHY: Ralph Gibson

Employing elements of the now-familiar postmodern graphic-design vocabulary yields a CD package for Hollywood Records with a limited color palette that exudes cool.

ART DIRECTOR: Jennifer Tough

CREATIVE DIRECTOR: Dave Snow

PHOTOGRAPHY: Robbie Caponetto

Burdick designed this brochure-and-booklet set for the Getty Research Institute for the History of Art and the Humanities.

ART DIRECTOR: Anne Burdick

Burdick serves as the Web site designer and design editor of the online literary journal *electronic book review* (www.altx.com/ebr/), for which she created these linked pages.

ART DIRECTOR/PHOTOGRAPHER:
Anne Burdick

reVIEWS

ebrINFO

riPOSTe

threads

ebr 6 image+narrative WINTER 97/98

ebr5 (electro)poetics spring 97

ebr5+ w(ebr) supplement spring 97

ebr4 critical ecologies winter 96/97

ebr3 writing (post)feminism fall 96

ebr2 the politics of selling out spring 96

ebr1 the electronic muse winter 95/96

threads

6

Out is In, Off the Page/
Now Online--Cool
Martina E. Linnemann

One can envision novels printed on scrolls, on globes, on moebius strips, on billboards, or not printed at all but produced on electronic or video tape, or acted out on stage.
--Ronald Sukenick, "The New Tradition in Fiction"

Over twenty years ago, Ronald Sukenick pointed to the possibility of novels moving outside of their traditional print format as his novel _Out_ has recently done, going on-line at _altx_. But back then, Sukenick regarded it as a move in the wrong direction. "To complain that a novel can't escape its binding," he argued, "is like complaining that the mind can't escape from its skull." What was needed, he proposed, was a rethinking of the novel form within its print medium, a reconsideration of the concrete, technological reality of the book and the use of its three-dimensional and visual nature to work together with the narrative embedded in it.

First published in 1973, _Out_ exemplified Sukenick's theory in its use of typography to support textual meaning, but also to create visual meaning independent of the text. Specifically, the novel is divided into ten chapters, numbered in reverse order. Each chapter is itself made up of paragraphs containing the same number of lines as the chapter number. Thus the paragraphs shrink by one line with each new chapter. Chapter 1, the last chapter, contains nothing but paragraphs of a single line that drive toward the end, a "0," which is followed by pages of white space as if the text has moved completely out of the book.

Out is not the only example of what can be called the "typographical novel," of course. A brief list of others published about the same time in various parts of the world would include: Julio Cortázar's _Rayuela_ (1963) in Argentina while from Great Britain came B.S. Johnson's _The Unfortunates_ (1969), Christine Brooke-Rose's _Thru_ (1975) and Alan Burns's _Dreamerika!_ (1972).

Ph.D

PRINCIPALS: Clive Piercy,
Michael Hodgson
FOUNDED: 1988
NUMBER OF EMPLOYEES: 10

1524A Cloverfield Boulevard
Santa Monica CA 90404
TEL (310) 829-0900
FAX (310) 829-1859

Budgets, deadlines, unexpected delays, or pesky "creative differences" with clients notwithstanding, a lot of a designer's work can—and, for many, should—be fun. For Ph.D's British-born, California-embracing founders, Michael Hodgson and Clive Piercy, an admitted commitment "to injecting rigor and fun" into the wide range of advertising, packaging, and graphic design projects that their studio undertakes is a matter of artistic policy. It shows, too, in an idea-loaded portfolio that snaps with a smart use of color and striking, often witty, but never gimmicky type treatments. Hodgson and Piercy acknowledge the solid place that tradition holds in their lives and outlooks at the same time that they savor the openness that their adopted American social setting and professional environment have provided. The blend of humor and serious-minded, design-powered problem-solving that characterizes much of their work can be seen in their wonderfully theatrical *Digital Junkyard* installation, an exhibit booth for Virgin Interactive Entertainment. Bright color and silhouetted or closely cropped photos or illustration details are other hallmarks of Ph.D's designs, which can powerfully rejuvenate a generic or overlooked form. Some good examples are the shoeboxes that Ph.D's designers created, in a series of related designs, to hold and promote Bloch brand footwear, and their fold-out brochures for Raisins.

Festive colors, warm in character, and a pared-down use of type characterize many Ph.D designs. So, too, does the use of closely cropped photos of details of subjects that gives them an iconic stature, as in this series of brochures for the Peerless Lighting Corp., and in these book designs for the publishers William Morrow and Chronicle Books.

ART DIRECTORS/DESIGNERS: Clive Piercy, Michael Hodgson

PHOTOGRAPHY: Michael Hodgson, Victoria Pearson

ILLUSTRATOR: Ann Field

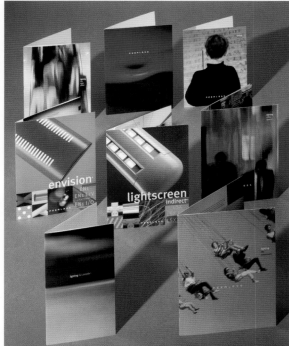

Stationery for Life's a Banquet displays the mix of humor and high style that distinguishes much of Ph.D's work.

ART DIRECTORS: Clive Piercy, Michael Hodgson

DESIGNER: Michael Hodgson

ILLUSTRATOR: Greg Clarke

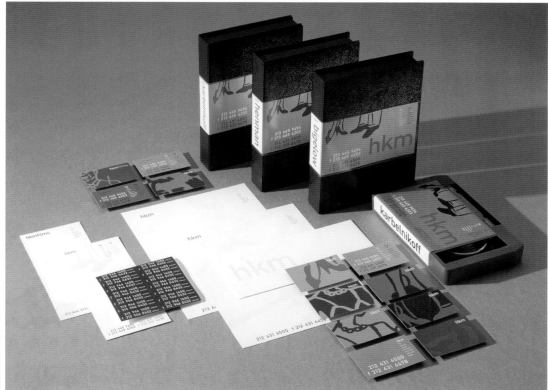

Bright colors and silhouetted or closely cropped photos or illustration details are hallmarks of Ph.D's designs. These elements or techniques can rejuvenate a generic or hitherto overlooked form. Examples include shoeboxes that hold and promote Bloch brand footwear. This typical Ph.D touch also turns up in fold-out brochures for Raisins and in an identity system for HKM Films.

ART DIRECTORS: Clive Piercy, Michael Hodgson

DESIGNERS: Carol Kono, Clive Piercy

PHOTOGRAPHY: Victoria Pearson, Ty Allison, Catherine Ledner, Ron Slenzak

The combination of humor and serious-minded, design-powered problem-solving that characterizes much of Ph.D's work can be seen in the studio's theatrical *Digital Junkyard* installation, an exhibit booth for Virgin Interactive Entertainment.

ART DIRECTOR/DESIGNER: Clive Piercy
FABRICATOR: Scenario, Exhibit Group

PRINCIPALS: Billy Pittard,
Ed Sullivan
FOUNDED: 1987
NUMBER OF EMPLOYEES:
180 worldwide,
125 in Los Angeles

3535 Hayden Avenue
Culver City CA 90232
TEL (310) 253-9100
FAX (310) 253-9160

PITTARD SULLIVAN

With 125 employees in their Los Angeles office alone—they also have branches in New York, Munich, and Hong Kong—and more than a decade of award-winning innovation behind them, Pittard Sullivan co-founders Billy Pittard and Ed Sullivan have fashioned a leader among design studios specializing in the development and marketing of telecommunications imagery for the entertainment industry. From the opening credits for an American television series like *Falcon Crest* in the late 1980s to trailers for feature films like Disney's *The Little Mermaid*, and logos for broadcast and cable TV channels around the world, Pittard Sullivan has always concentrated on branding. "A broadcast identity should be instantly recognizable by the viewer," Pittard has said, and his firm's approach is unabashedly driven by its clients' strategic marketing concerns. Pittard Sullivan is also extensively involved in Web site, interactive, and other new-media graphic-design applications. Stylistically, its work ranges from the straightforward, colorful wholesomeness of its titles for Disney TV programming to the edgier, contemporary looks of those for the TV series *ER* and *Gun*. Pittard Sullivan encourages its designers to pursue their own pet projects, which can—and often do—lead to unexpected, useable solutions. "What we communicate is far more important than how we produce the message," Pittard observes.

A now-familiar, distressed typeface and the kind of murky, ambiguous imagery that have become hallmarks of much hip, late-nineties graphic design appear in the main-title sequence for the ABC television series *Gun*.
DESIGNER: Earl Jenshus
CREATIVE DIRECTOR: Jennifer Grey

Considering the vast scope and diversity of Pittard Sullivan's designs, this interface for Web TV is relatively conservative and simply straightforward, but it must communicate with a more general, broader audience of end users, too.
DESIGNERS: Ron Romero, Inge Krei, Brad Beesley
CREATIVE DIRECTOR: Brian Black

Pittard Sullivan's identity campaign for Kabel 1 features vivid visual puns on the logo the firm created for this television channel in Germany.
DESIGNER: Mark Johnston
CREATIVE DIRECTOR: Ann Epstein

Designer/creative director Lauri Jones makes vaguely abstracted references to the familiar typefaces seen on athletic uniforms and, within a single frame, creates a sensitive, documentary feeling with her sports-image campaign for the Lifetime cable TV channel, which aims its programming at female viewers.

A series of identity spots for children's programming on France's TF1 national television channel features the bright color and whimsy that grab young viewers' attention.
DESIGNER/CREATIVE DIRECTOR:
Judy Korin

Logo for Deirdre Sullivan Catering
and Event Planning, Los Angeles.

Here, Pollen applies her
familiar layout techniques to a
monochromatic spread for an
Otis College of Art and Design
exhibition catalog.
PHOTOGRAPHY: Scott Lindgren

Gently alternating type weights
and sizes, a subtly varied color
palette, and a certain crispness
characterize Pollen's identity
system for a new-media company.

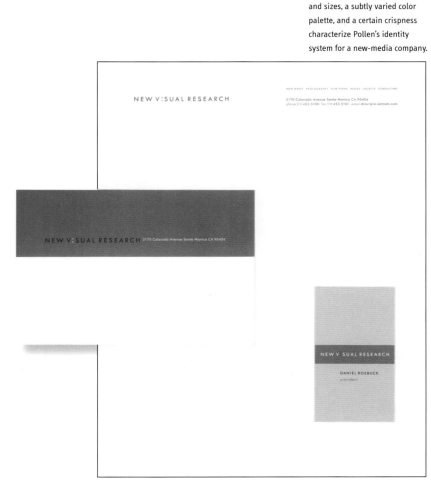

Exuberant color and erratic
shapes lend rhythm and
visual texture to this proposed
identity scheme and poster for a
Brazilian cultural institution
linked to the Getty Conservation
Institute.

RESTORATION OF KAUFMANN HOUSE The Kaufmann House was originally designed by architect, Richard Neutra in 1946. The site, located in what was a rugged desert in the late 1940's, is now a residential neighborhood. The purpose of the restoration was to return the house to its original form, size, and aesthetic integrity as expressed in the photographs of the house taken by Julius Shulman in 1947. By utilizing archival drawings and specifications in the Special Collections Department of the UCLA Research Library in conjunction with Shulman's photographs, the original appearance of the house was established.

Originally conceived as "a ship on the desert", the Kaufmann House drew its aesthetic identity from, in Neutra's words, "Juxtaposing a foreign, man-made construct onto a wild, unrefined, natural setting." This dialogue between natural and synthetic space was expressed through the interplay between the inside and the outside in the transparent wall planes, overhanging roofs and floor planes which extend into the exterior patios. Thus, an important challenge of the restoration was to recreate this exchange between **inside** and **outside** space despite the transformation of the surrounding context from a desert to a residential neighborhood.

The clients and the architects developed a philosophy toward the restoration which emphasized a meticulous reproduction of the original design. Additions which were not part of the original design were removed. One of the most important goals of the restoration was to match the level of craftsmanship inherent in the original construction. Research was conducted to accurately recreate architectural components which are no longer in production.

The basic approach to the restoration was to try to save all of the original materials. If a material was so damaged that it could not be saved, then the challenge was to salvage as much of the material as possible by replacing what could not be restored. The decision as to whether or not to replace a part or the whole of any material was made only after significant research was conducted and opinions were obtained from various experts. The replacement of the smallest material or fixture was treated as a very serious issue.

Well-balanced in hues and in the relative placement of line art, photos, and text blocks, promotional spreads for Marmol & Radziner Architecture & Construction bridge classically modern and postmodern aesthetics.
PHOTOGRAPHY: Julius Shulman, Eric Koyama

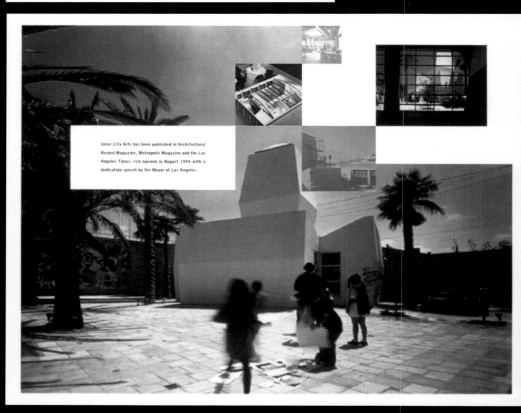

Inner City Arts has been published in Architectural Record Magazine, Metropolis Magazine and the Los Angeles Times. ICA opened in August 1994 with a dedication speech by the Mayor of Los Angeles.

The logo for L.A.-based jewelry designer Suzanne Felsen combines her initials so that a simple, graceful *S* also suggests an *F*.
CREATIVE DIRECTOR: Shiffman Young Design Group.
PHOTOGRAPHY: Rob McHugh

Preliminary sketch of a logo
for a public park in Pittsburgh,
Pennsylvania.

1997–98

EVENINGS *for* **educators**
LOS ANGELES COUNTY MUSEUM OF ART

Pollen's typeface mélange gives
an updated, academic flavor to
this press kit for the education
department of the Los Angeles
County Museum of Art.
CREATIVE DIRECTOR: Jim Drobka

PRAXIS: DESIGN

PRINCIPAL: Simon Johnston
FOUNDED: 1989
NUMBER OF EMPLOYEES: 2-3

254 Tranquillo Road
Pacific Palisades CA 90272
TEL (310) 459-9481
FAX (310) 459-6026

If the capacity to traverse vast distances in seconds, bridge different societies through a global language of images, and race through time zones with a mouse click in one round-the-clock, never-sleeping world have become the hallmarks—and mantras—of the digital revolution, then work like Simon Johnston's of Praxis: Design has helped give visual expression to the computer-driven culture it has spawned. Late twentieth-century technology itself, especially that of the computer, and its interfaces' overall look and character, inform Johnston's designs for such works as his flyer for a conference in Japan on interactive multimedia; that piece also existed as a projected, animated poster. Johnston can also bring a sober touch, in print, to the frenetic visual outpouring of the age; with lightly tinted, monochromatic photographs, for example (an element that he uses elsewhere, too, in background layers), his layouts for the *Bulletin* and other publications of the J. Paul Getty Trust at once convey both a friendly and a serious tone appropriate to such a temple of high culture.

designing
interactive
multimedia '95

日時：1995 年 3 月 1日（水）13:00 ~ 19:30
3 月 2日（木）9:30 ~ 17:00
会場：北九州国際会議場
北九州市小倉北区浅野三丁目 9 — 30

With its overlapping layers of text and visual information suggesting horizontal and vertical movement, and its familiar icons and pattern of punched-out holes, Johnston's flyer for a conference on interactive multimedia vividly evokes its subject.

An announcement card for an art exhibition uses blurry sans-serif type that echoes the show's odd, elusive-sounding title, *Nor Here Neither There*.

reception:
june 16
7–10 pm

artists:
Doug Aitken
Tom Burr
Willie Cole
Stan Douglas
Valie Export
Chris Finley
Suzanne Garrison
Ideal Copy
Sharon Lockhart
Mythter
Lorraine O'Grady
Spandau Parks
Cynthia Stewart
Nari Ward LACE's

curated by:
Charles Gaines inaugural
Paul McCarthy
Stephen Prina
Fran Seegull show in

Hollywood

A plain, raw-cardboard cover with a title sticker belies the simple sumptuousness of the color pages, with type-filled vellum overlay sheets, of this booklet describing a program involving Art Center College of Design students and various industries.

PHOTOGRAPHY: Steven A. Heller

design and industry:
the design associates
program at art center

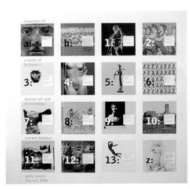

The square serves as the basic organizing principle in a two-sided poster and related, staple-bound booklet (made of the cut-up poster itself) for a lecture series at the Getty Center.

Overlapping, contrasting
black-and-white streams of
type help give a more dramatic
sense of depth to a TV commercial
for Blue Cross/Blue Shield.
ART DIRECTORS: Simon Johnston,
Tony Kaye
TYPOGRAPHY: Simon Johnston
DIRECTOR: Tony Kaye

An announcement card for Rooftop
Communications bears the firm's
Johnston-designed logo.

ART DIRECTOR: Barry Deck
FOUNDED: 1992

2812 Santa Monica
Boulevard, Suite 204
Santa Monica CA 90404
TEL (310) 828-0522
FAX (310) 452-8076

RAYGUN PUBLISHING, INC.

Raygun is the Los Angeles-based music-and-style book for the nineties' cola-guzzling, pierced-body set, and for many young designers and would-be designers, this is it: the beacon, the standard-bearer, and the Holy Grail of late-postmodernist graphic design. That stature and *Raygun*'s broad influence owe everything to the contributions of the now-legendary high-school teacher and surfer-turned-graphic designer David Carson, who became the magazine's art director in 1992. Carson gave *Raygun* its unique look by breaking every rule of magazine design. In work that some critics have derided as chaotic, decadent, and downright unintelligible, he threw out organizing grids, regular text columns, and type treatments reflective of modernist stalwarts' time-honored "hierarchies of information." Instead, Carson sought to visually convey the emotion of a text. Crossed with the crude-is-good "grunge" aesthetic of the mid-1990s, that approach found expression in layouts dense and jammed—or sometimes, sparse and only sprinkled—with hard-to-read, rough-edged, distressed typography. Words, lines, or paragraphs broke erratically or even ran backwards; blurry, manipulated images collided with or melted into each other. These techniques have since become part of the lingua franca of hip advertising and magazine design. Since he left *Raygun*, other art directors have continued to work in the mode Carson originated. The magazine's sister publications, *Bikini* and *Sweater*, echo that still-evolving style in a more distilled manner.

Bikini, a square-format sister magazine of *Raygun* aimed at young male readers, serves up a testosterone-boosting menu of babes, booze, rock-music stars, action, and other macho-cool stuff to America's skateboarding, headphone-wearing masses. Although many of its headline treatments and layout tricks appear *Raygun*-derived, *Bikini*'s visual style and editorial content are in many ways more direct and less dramatic than those of its pioneering predecessor.

ART DIRECTORS OF ISSUES SHOWN:
Paul Venaas, Jerôme Curchod, Ryan M. Ayanian

Bikini

>> action >> film >> sergio >> rock >> roll >>

$2.99US $3.99CAN 04

Rachel True

0 0 3

Matchbox 20 Test Drive	Anka Radakovich	Snowboarding	Curve
Iceland Travel	William Gibson	Ghost Hunting	Gangstarr
Chef Boyardee	Dave & Johnny Navarro	Stilt Walking	16 Horsepower

When Rachel True grew up in New York City's East Village, she went to P.S. 19. "That school had every kind of person you could ever imagine," she remembers, "and a lot of them were first generation or not even; they'd just come over themselves. So we celebrated Hanukah, we learned the dreidel song, we celebrated Chinese New Year, we had the Korean holidays – we had every holiday you could image, and assemblies for them all. So it was amazing for a little first grader to be watching the Chinese dragon at New Year, which is something I don't think a lot of Americans get to experience as kids."

But things changed drastically in high school when her parents moved the family upstate to Edinburg, New York, a town not known for...well, anything. And though Rachel now realizes that the move was a good one – "Had I grown up in New York City, I think I'd be crazy," she says – and while she now realizes that her time in the sticks helped her become the good person she is today, she doesn't exactly look back at that time with rose-colored glasses.

"When I moved to upstate New York," she recalls, "it was an all-white school, except for me and my brother – and my brother dropped out. And the first day, after school, some kids started fighting, and they started chanting, 'Fight! Fight! A nigger and a white!' So that was kind of weird, because, first of all, it was two white people fighting, and secondly, why would they even know this? I just thought, 'Great, I'm in for it.' Not that I hadn't experienced that in New York City – my little Italian neighbors, their older relatives were pretty brutal with being racist – but this was my first full-on. 'I live in the midst of this, I can't walk away from it.' It was totally like 'We've never seen a black person before, and we don't think we like you.'"

Which isn't to say that Rachel didn't try her best to fit in. "I was kind of introverted and shy when I was a kid," she says, "but also really adaptive. One thing about myself – and I think that's what made me, in the end, be an actor – is that I could adapt. Everyone's being silly and kooky, so I would do that. I could mold to my situation, which I kind of stopped doing because, in the end, I was trying to please people by being 'What do you want me to be?'"

Even so, she still had trouble. "There were hicks pulling out shotguns when me and my dog walked by because they don't want me anywhere near their property," she recalls. "There was also this dance I wanted to go to, and my parents – who were rightfully paranoid – were like, 'No, you can't go to the dance because you might get beat up. People might do stuff to you.'"

Dealing with that kind of blind hatred can have a strange effect on people, turning them into *Simpsons*-loving/poetry-reading/video game-playing/self-referencing idiots, techno-hating recluses who live in cabins, or blind haters themselves. But in Rachel's case, it made her a better person (thank god). And that – coupled with her mixed parentage (dad's white, mom's black), her experiences at P.S. 19, and an upbringing she fully admits was "middle class" – would later have an effect on the kinds of roles she'd get as an actress.

Consider her part in *The Craft*, the pre-*Scream* teenage witch movie that might as well have been called *The Lost Girls*. The part was originally written for a white girl, and aside from a comment (which actually seemed tacked-on and unnecessary) that explained a girl's hatred toward Rachel's character as being race-motivated, the part could've easily been played by any number of white actresses. And then there's her occasional role on *The Drew Carey Show*, where she plays Drew's middle-class neighbor. Again, the character's race doesn't come into play; it hasn't even been mentioned.

"They seek me out, I seek them out, it kind of just meets in the middle somewhere," she says of the non-racially motivated roles she's had over the last couple years. "And I think the thing that people have responded to in my movies is that I'm a black girl, but I can hang with whoever. It doesn't matter if it's a group of black kids in a movie, or white kids, or Asian, we're all just people hanging out, so that's it, we all get on. And I actually really like that about my career.

"I think it's because of how I grew up," she continues. "I'm a middle class girl. And growing up mixed in a mixed family, and at the end of the century, all of these things kind of lend themselves because I do believe the future isn't a black role or a white role, it's just a role. We're not all pimps, thieves, bad-asses, and hookers with hearts of gold, and unless the role specifically calls for it, I think it's a more interesting choice, as an actor, to not play it that way."

It was this attitude that helped her get her role in *Half-Baked*, a pot comedy which she describes as a really funny, '90s-updated Cheech & Chong kind of movie. "I play Mary Jane," she explains, "pun intended, who is the only non-pot smoker in the whole entire movie. And I think I got the part in the end because...Just because Mary Jane doesn't smoke pot, there's no reason why she has to be uptight. But I think a lot of people went in there and played it like a PSA: 'Don't smoke pot. Very bad for you.' But there's plenty of hip, cool people who don't smoke pot, so I just thought she was a regular gal."

Being as versatile as a Swiss Army Knife is, in most professions, a good thing. But in Hollywood, where people tend to narrowcast actors, having any kind of range is sometimes as useful as, well, a Swiss Army Knife if the blade is dull, the corkscrew has been straightened, and the spork is missing. And as anyone who's tried to eat on a camping trip will tell you, ya gotta have the spork.

For Rachel, it's not about the spork, but about the roles. And she's been lucky in that respect because she's gotten most of her parts not because she's black, but in spite of it. "It's still at that stage," she says. "But even last week, my people had to push really hard because it was an all-white project. There's 15 characters in the movies, it's an ensemble thing, and yet they had to push really hard to get me in because everybody *had to be white*. And the way I see it, 15 people and everyone's got to be white? I don't think so.

"But then I went on an audition where, the way the script was written, there was no way they could've cast a black person. And I was sitting there going, 'What am I doing here?' But then I thought, 'No, it's cool, because there's other parts in this, and there's a chance that this person will dig what I'm doing and understand that I'm just an actor, I'm not a black actor.'"

Which isn't to say that Rachel wouldn't play a pimp, a thief, a bad-ass, or a hooker with a heart of gold, especially if it meant working with a director on the level of Scorsese or Bertolucci. "The

The Rachel Papers

00 50

Sweater is a small-format, hipster's guide to life after dark in major U.S. cities. It distills some of the lessons learned from its sister publications but goes its own way graphically with big headlines that buck right up against, and sometimes incorporate, photos in the layouts of the stories they accompany. The magazine's pages convey a sense of spontaneity and are generally more readable than those of *Raygun*. *Sweater* is distributed "free, in cool places."

ART DIRECTOR OF ISSUES SHOWN:
Jerôme Curchod

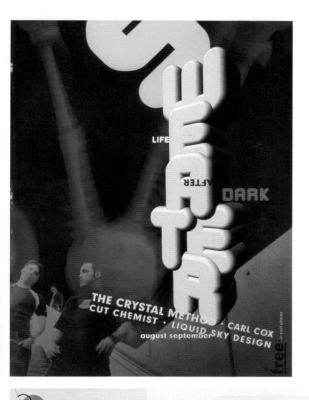

LIFE

AFTER

DARK

THE CRYSTAL METHOD · CARL COX
CUT CHEMIST · LIQUID SKY DESIGN
august september

free ...in cool places

Photograph by Trevor O'Shana · Grooming
by Kristie Anderson @ The 1101 · Styling
by Walter Cessna · All clothes Helmut Lang

ACTOR/MODEL **DANIEL RIVAS** IS ONE LUCKY SON OF A BITCH. **WALTER CESSNA** ISN'T PARTICULARLY LUCKY.

ake Me to the RIVAS

How does a disarmingly cool Mexican-Venezuelan (with a little Russian thrown in for good measure) actor, model, non-driver and self-admitted Star Wars toy freak from the Upper East Side of Manhattan end up in Hollyweird shopping around a screenplay that he wrote with his ex-girlfriend and living that groovy Cali lifestyle? For 21-year-old Daniel Rivas, it was a long, bumpy and extra winding road, mixed with a lot of cab rides that he can now finally afford.

"I feel like I'm going on 60 sometimes," Rivas says, squirming in his seat and most likely thinking about the cigarette that he's rolling between his fingers. I'm struck by his weariness and the fact that this young man has the wisest looking eyes I've ever seen in someone his age. He's sporting a polyester pajama shirt over threadbare khakis and brand spanking new Gucci boots that look huge compared to his slight, slinky frame. His tattoos range from HR Geiger aliens to American

Indian and Inca tribal designs. "I'm about to get an Aztec calendar on my back," he says almost lazily, wiping a sleep booger out of his eye.

His mother is the semi-famous Hispanic theater actress Alisia Kaplan, and like most parents in the biz, she kinda forced him to go on auditions at a very early age. "I did a lot of extra work where I got picked out for little cool cameos. It was always easy, even when I went through my punk period and got all tattooed and pierced. That made them only want me more," he laughs. Small roles in films like *Me & Max* and *Sid & Nancy* led to modeling gigs, money and then trouble. "I don't wanna be the anti-heroin poster child, but drugs really had me fucked for awhile," he says.

"I've always supported myself and pretty much been on my own since I was a teenager. Then when I got successful as a model, I didn't know how to handle it all, especially my money." But no matter how bad things got drug-wise, the jobs just kept coming. Daniel landed the CK campaign and was soon seen on billboards and buses everywhere. "It was really weird," he says. "None of my accomplishments meant anything to me because I was so fucked up. So I decided to go to LA and get clean. What a joke that was."

He continued to make movies, shooting intense scenes in *The Professional* and *The Basketball Diaries* that ultimately ended up on the cutting room floor. His life seemed to be taking a similar route. "In NYC, the consequences of being a junkie were a lot less severe than in LA," he says. "The final straw was when I got arrested. I know it sounds like a cliché, but that really scared the shit out of me." Rivas decided to get clean and enrolled in a rehab program. When not freaking out, he would write poetry, and helped his ex-girlfriend Amber Taylor finish their screenplay *One Lucky Son Of A Bitch*, a sort of autobiographical dark comedy about a guy who moves to LA. It's been optioned by ICM.

"I've been writing in journals since I was 16. Then I got a word processor and really got into it. I would write stories about what I was doing, which at the time was taking drugs with rich kids and fucking off. Now my stuff is a lot different." He likes to listen to Marilyn Manson, but "my girlfriend is really Christian and it freaks her out," and is currently reading *The Andy Warhol Diaries*. His favorite authors are, typically, William Burroughs and Hunter S. Thompson. "I like how they were able to be so prolific even though they were completely fucked up."

Rivas has just successfully completed a methadone program ("I had to turn down all these cool jobs because I had to complete the program and was so sick all the time") and lives in Hollywood. He just wrapped the indie *Mascara* (co-starring Amanda de Cadanet) and is currently filming *She Die* with director Gabriela Retes. Also look for him in the new Mountain Dew and Planet Hollywood commercials, "which were cool cause I got to hang out with a bunch of girls and act cheesy." He still doesn't drive, uses cash instead of a credit card and loves his Kiss doll collection. Asked what he likes about LA, he replies, "Not the Sky Bar!" and laughs out loud. Just like the little punk he is.

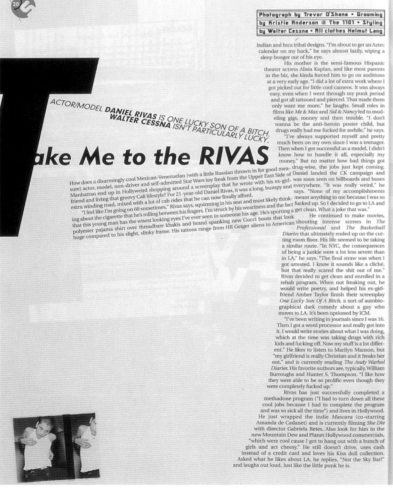

That nothing is normal about a *Raygun* layout has become the influential magazine's norm, as its fashion and feature spreads, and even its covers, show. In its pages, David Carson, and the art directors who have followed his lead, have painted with type and images in order to visually convey the emotion of each text. Ironically, the relative ease with which so many imitators have adapted *Raygun*'s looks demonstrates the essential cohesiveness of its style-defying style.

ART DIRECTORS OF ISSUES SHOWN: Chris Ashworth and Scott Denton Cardew; Robert Hales; Chris Ashworth/Substance; Chris Ashworth and Amanda Sissons/Substance

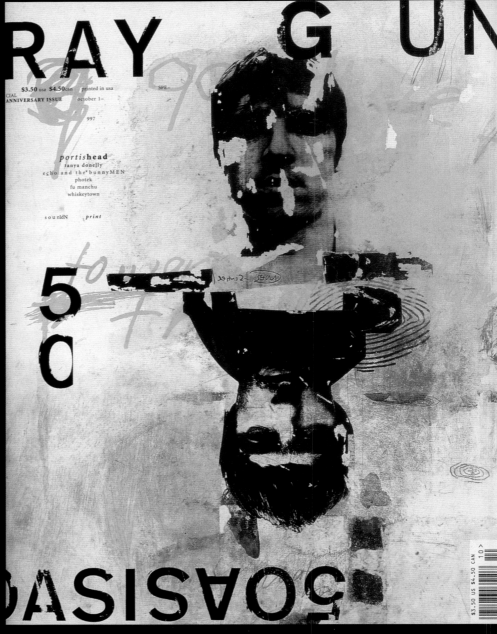

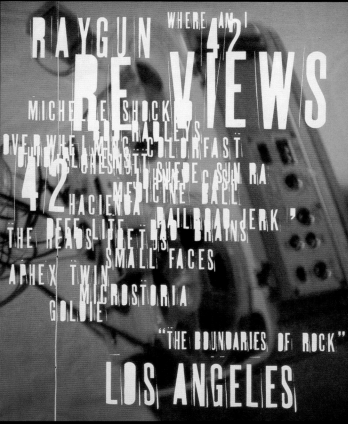

RAYGUN WHERE AM I 42

REVIEWS

MICHELLE SHOCKED

THE DELGADOS ... LOW

OVERWHELMING ... COLORFAST

JUTE ... GILES NUTT ... SUEDE ... SUN RA

42 HACIENDA ... MEDICINE BALL

THE HEADS ... LITE ... RAILROAD JERK

THE POETESS ... BAD BRAINS

SMALL FACES

APHEX TWIN

MICROSTORIA

GOLDIE

"THE BOUNDARIES OF ROCK"

LOS ANGELES

SUPER SUPER

DRAG DRAG

CHRISTIAN MARCLAY

unitryb

HED

SPIRAL SCRATCH

BY CARLE VP GROOME.

PHOTOGRAPHY BY MATTHIAS CLAMER

unitryb

PRINCIPAL: Rebeca Méndez
FOUNDED: 1985
NUMBER OF EMPLOYEES: 3

1023 Garfield Avenue
South Pasadena CA 91030
TEL (626) 403-2122
FAX (626) 403-2123

REASONSENSE

With their type-crunching, type-bending, dramatic visual textures and fluid rhythms, Rebeca Méndez's designs express the sometimes audacious power of today's computer-driven graphics and perfectly capture the spirit of a city that is in constant motion. In Méndez's poster for a Rice University symposium called *Architecture After Individualism*, a forest of hairline rules barely contains—or helps to generate—the design's restless energy; here, ironically, Méndez says she took her cue for the way she organized the poster's information from the often dull but "highly structured graphic systems found in government documents, where the 'individual' is most absent, such as income-tax forms." Like bank checks, the piece is printed on safety paper. Méndez's *Faultlines* booklet for UCLA's Department of Architecture and Urban Design attempts to communicate through its structure, with a centerfold that opens to a total length of 65 inches. "It's beyond almost anybody's wing-span, and gives a sense of ever-evolving and multiplying systems and of continuity," the designer muses, herself both somewhat daunted and delighted by the irresistible impact and tactile appeal of such handsomely printed pieces. With its sense of adventure and its conceptual substructures, Méndez's work is emblematic of the times and the environment that have helped to shape it.

Representing Mexico, Méndez was one of 12 designers commissioned by the city of Hannover, Germany, to create a poster announcing the international World Expo 2000, which will take place there. Its themes: continuity and change, which are hinted at by the human torsos flanking each side of the image.
PHOTOSHOP OPERATOR: Stephan Argendorf
ASSISTANT: Ulrich Steffener

1 de Junio–31 de Octubre
Exposición Mundial en Hanover
EXPO
respira
2

XPOster'97: 12 Designer aus 12 Ländern für die Weltausstellung EXPO 2000 in Hannover
Die Weltausstellung in Hannover 1. Juni–31. Oktober 2000
Design: Rebeca Méndez, México
Assistants: Ulrich Steffener and Stephan Argendorf

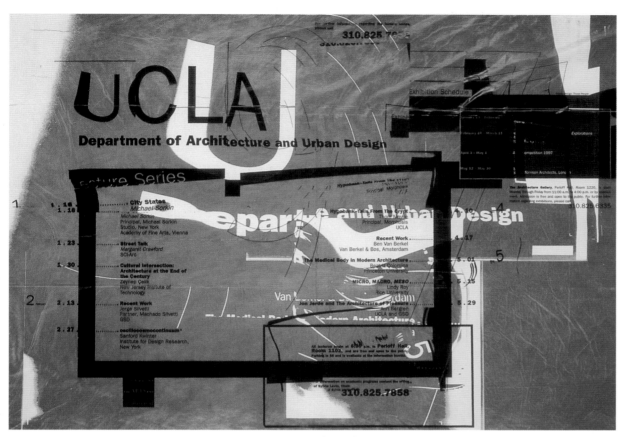

Because garbage is found everywhere in today's cities, Méndez used flexography to print this poster for a lecture series on urbanism on actual trash bags. She also admired the material's "formlessness and fluidity."

ASSISTANT DESIGNER: Bryan Rackleff

Although it was inspired by what Méndez calls the "highly structured graphic systems" found on many bureaucratic, government-issued forms, her poster for a Rice University symposium exudes a certain restless energy.
DESIGNERS: Rebeca Méndez, Bryan Rackleff
ASSOCIATE DESIGNER: Yoon Lee

Méndez gave this issue of *Faultlines*, a UCLA publication, a centerfold that opens up to a length of 65 inches.
DESIGNERS: Rebeca Méndez, Yoon Lee

Familiar signs for air, road, and pedestrian traffic inspired a Web site design for go2net, an interactive-media and technology company; this navigational system leads users from general to specific information.
CONCEPT/CREATIVE DIRECTOR-DESIGNERS: Rebeca Méndez, Bryan Rackleff
ASSISTANT DESIGNERS: Kevin Bauer, Jorge Verdin

In Méndez's cover for a book on "the entropic city" that is heavy on postmodernist theory, the ghosts of fractured letterforms in the title sputter across the dust jacket. *Slow Space* was issued by the Monacelli Press, a publisher of upscale books about art, design, and architecture.

REVERB

PRINCIPALS: Somi Kim, Lisa Nugent, Susan Parr
FOUNDED: 1991
NUMBER OF EMPLOYEES: 10

5514 Wilshire Boulevard
No. 900
Los Angeles CA 90036
TEL (213) 954-4370
FAX (213) 938-7632

Modern graphic design long ago learned that its effectiveness could be measured by the versatility of its application, especially in coordinated schemes consisting of everything from matchbook covers to billboards. In our late-postmodern era, visual communications specialists face an even wider array of media by and for which to produce their designs. They must understand these distinctive modes of conveying information both conceptually and practically before creatively exploiting their potential. It is this grounding in both approaches, one modern, one more postmodern in outlook, that Somi Kim, Lisa Nugent, and Susan Parr and their colleagues at ReVerb, a self-styled think tank, bring to the task, as they put it, of "problem solving across many media platforms." Like many studios today, ReVerb is as likely to design Web site pages as it is to take on more conventional projects like exhibition catalogs and posters. "We find it increasingly difficult to pinpoint our [creative] process or product in a simple descriptor," explains Kim, who notes that the ReVerb team, in assessing an assignment's problems, objectives, and possible solutions, "uses language and observation to create or identify stories and give them visual expression." Whether stylistically more complex, as in a poster for the Power Phone, or pared-down and instructional, as in an annual report for Netscape, or more literally illustrative, as in presentation boards for MTV, much of this firm's work gives visual expression to what genuinely interests its designers: the relationships that exist between culture, science, and society, and how their overlapping forces affect how we think, see, and feel.

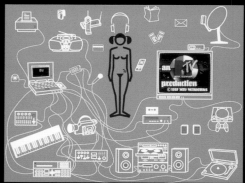

These media-landscape charts, prepared for a presentation by client MTV Music Television, literally refer to and depict relationships between science and technology (in the form of household appliances) and society (in the form of human consumer-users).
ART DIRECTORS: Somi Kim, Lisa Nugent, Susan Parr
DESIGNER/ILLUSTRATOR: Beth Elliott

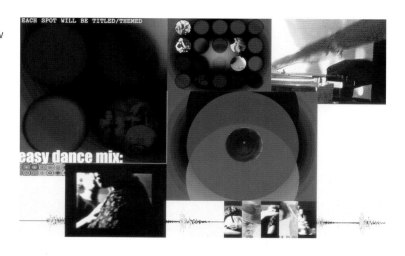

ReVerb prepared this "DJ of All Media" concept board for client MTV Music Television.

CREATIVE DIRECTORS: Lisa Nugent, Susan Parr

DESIGNERS: Lisa Nugent, Susan Parr, Jens Gehlhaar

The cover of this catalog for an exhibition at the Armand Hammer Museum and Cultural Center at UCLA features a detail of a painting of the Los Angeles County Museum of Art on fire by Edward Ruscha.

ART DIRECTOR: Somi Kim

DESIGNERS: Somi Kim, Beth Elliott, Jérôme Saint-Loubert-Bié

A self-promotional New Year's greeting card for ReVerb makes clever use of a movie-theater marquee.
ART DIRECTORS: Somi Kim, Lisa Nugent, Susan Parr
DESIGNER: Somi Kim
PHOTOGRAPHY/ILLUSTRATOR: James W. Moore

Using circulation as a metaphor for biological and technological processes, this project explores how culture informs science, and vice versa. Blood—the river of life, the substance thicker than water—is addressed through an interweaving of individual and collective voices, telling tales of myth and medicine through the ages, and engaging methods of information management that question what we know, how we know it, and why we care.

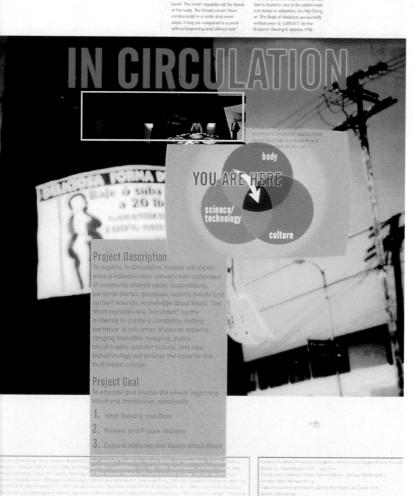

IN CIRCULATION

YOU ARE HERE

body

science/technology

culture

Project Description
To explore *In Circulation*, visitors will experience a kaleidoscopic conversation comprised of commonly shared ideas, superstitions, personal stories, practices, historic beliefs and current scientific knowledge about blood. The short vignettes are "circulated" by the audience to create a constantly shifting narrative. A rich array of source material, ranging from DNA mapping, public blood supply, popular culture, and new biotechnology will provide the basis for the multimedia collage.

Project Goal
To educate and involve the viewer regarding blood and transfusion, specifically:

1. What Blood Is and Does
2. Present and Future Realities
3. Cultural Attitudes and Beliefs About Blood

These layouts, originally conceived as part of an installation for an exhibition called *Digital Campfires*, address some of the themes that can be found in ReVerb's work, like the overlapping forces of science and culture.
ART DIRECTORS: Somi Kim, Lisa Nugent
DESIGNERS: Somi Kim, Lisa Nugent, Winnie Li

ReVerb's annual report for Netscape Communications, the maker of popular Internet browsers, is straightforward, even instructional, in its presentation of information about the company's structure and operations.
ART DIRECTORS: Somi Kim, Lisa Nugent, Susan Parr
ASSISTANT DESIGNER: Winnie Li
PHOTOGRAPHY: Doug Menuez
ILLUSTRATOR: Doug Chezem
PRODUCER/EDITOR: Darcy DiNucci

Net Results 1996

ReVerb's designers created this
stylistically complex poster for
iMagic Infomedia Technology,
of Hong Kong, to promote the launch
of its Power Phone.
ART DIRECTOR: James W. Moore
DESIGNERS: James W. Moore, Richard
Leighton, Jamandru Reynolds

A Netscape company timeline and Web site banners show how ReVerb's designers interpret and work with the software program's familiar graphic look.

ART DIRECTORS: Lisa Nugent, *timeline*; Somi Kim, Susan Parr, *banners*

CREATIVE DIRECTOR: Robin Bahr and/or Hugh Dubberly/Netscape

DESIGNERS: Oliver Laugsch, with Beth Elliott, *timeline*; James W. Moore, Oliver Laugsch, *banners*

PRODUCER/EDITOR: Darcy DiNucci, *timeline*

PRINCIPALS: Clifford Selbert,
Robin Perkins
FOUNDED: 1980
NUMBER OF EMPLOYEES: 45

1916 Main Street
Santa Monica CA 90405
TEL (310) 664-9100
FAX (310) 452-7180

SELBERT PERKINS
DESIGN COLLABORATIVE

Clifford Selbert was trained as a landscape architect and later expanded his reach to include graphic design, product design, and environmental communications. Robin Perkins, whose background is in graphic design, is also deeply interested in sculpture and public art, urban design, and landscape architecture; she keeps a fully equipped sculpture studio in Boston. Coming from different areas of specialization, over the years, both Selbert and Perkins have learned—and to their clients, have emphasized—that a company's most valuable asset is its brand and the image portrayed by its corporate identity. This viewpoint is the cornerstone of all of their work, from packaging for Disney merchandise to large-scale, site-specific sculpture-signage. "We see sculpture as a form of nonverbal communication," Perkins has observed, pointing to work her firm has done in Jakarta, Indonesia, where zoning laws prohibited conventional signs at certain locations. Thus evolved the Selbert Perkins approach that uses "images and light rather than words," where necessary, to get a client's message across—and to help build or reinforce awareness of their brand. Selbert Perkins did this to memorable effect for the 1994 World Cup U.S.A. tournament; in another project, this design studio used signs, logos, and map/locator boards to create a unifying public-information system that effectively branded and gave a cohesive identity to a 20-town historic region of the Northeast. They have taken similar approaches to formulating comprehensive identity, branding, and information schemes for such clients as Stride Rite, the shoe retailer, and Sega Gameworks, an entertainment complex in Seattle. "We make sure that our ideas are very big, very powerful, very dynamic in the environment," Selbert has said of his company, which also maintains a branch office in Boston.

For the Stride Rite Children's Group, Selbert Perkins cleaned up a confusing hodgepodge of unrelated logos, packaging, and sub-branding in one comprehensive identity, branding, and merchandising system that allows all of the company's offerings to coexist intelligibly to distributors, retailers, and consumers alike. The new Stride Rite logo aims to reflect a sense of happiness, gender equality, and multiculturalism.

CREATIVE DIRECTORS: Robin Perkins, Clifford Selbert

DESIGNERS: Robin Perkins, Julia Daggett, Michele Phelan, Kamren Colson, Kim Reese, John Lutz

ILLUSTRATOR: Gerald Bustamante

PHOTOGRAPHY: Jim Webber

To help brand Chai Tai RiverFest, a new, twelve-story retail center in Shanghai, China, and to allude to the theme of global commerce, Selbert Perkins created this landmark communications element that hints at some Times Square-like razzle-dazzle.

CREATIVE DIRECTOR: Robin Perkins
SENIOR DESIGNER: John Lutz
DESIGNER: Seth Londergan
PROJECT DIRECTOR: Greg Welch

Selbert Perkins' vehicular and pedestrian directional systems for the Universal Studios amusement park in Florida are bright, bold, and color-coded, and they make extensive use of primary colors.

CREATIVE DIRECTOR: Robin Perkins
SENIOR DESIGNER: John Lutz

Selbert Perkins often uses large-scale, site-specific sculptures as signage; these elements of broader design schemes help define or reinforce a brand or an identity—in this case, those of a World Cup tournament held in the United States—in their own, often wordless, ways. "We make sure that our ideas are very big, very powerful, very dynamic in the environment," Selbert has said of his firm's approach.

CREATIVE DIRECTOR: Maury Blitz
FURNITURE DESIGN: Martha Schwartz

Selbert Perkins created this bright,
multi-panel fundraising brochure for
the libraries of the University of
Southern California.
ART DIRECTOR/CREATIVE DIRECTOR:
Rick Simner
SENIOR DESIGNER: Jamie Diersing
DESIGNER: Misha Strauss

From the main entrance to the food court and various retail outlets, a Selbert Perkins-designed signage system leads visitors on their way through the Sega Gameworks entertainment complex in Seattle.

ART DIRECTOR: Clifford Selbert
CREATIVE DIRECTOR: Brian Lane
SENIOR DESIGNER: Brian Keenan

PRINCIPAL: Maureen Smullen
FOUNDED: 1990
NUMBER OF EMPLOYEES: 5

85 North Raymond Avenue
Suite 280
Pasadena CA 91103
TEL (626) 405-0886
FAX (626) 405-1443

SMULLEN DESIGN, INC.

Maureen Smullen has some very funny friends, including Bugs Bunny, Daffy Duck, Tweety Bird, and Sylvester. But like her colleagues and her clients, including Warner Bros., Disney, and other media companies and retailers, Smullen takes her work as a specialist in "entertainment design," as she calls it, very seriously. Her small studio has also created original projects for the Ford Motor Company, Lockheed, the American Cancer Society, Southern California Edison, and many other high-profile clients. Smullen, who comes from a family of artists and designers—her grandmother was a painter, and her uncle attended Pasadena's Art Center College of Design and worked for Disney—studied at the University of California at Davis and at the Art Center, focusing on illustration. Being able to draw and paint, she observes, is "a skill that not enough designers have today." Likewise, as much as Smullen's team inescapably employs computers in its work, the designer notes that the ubiquitous, powerful machines have both "hurt and helped" graphic-design practice, leading to a homogeneity in type treatments and overall looks in which, sometimes, a certain "quality and level of sophistication [are] missing." Still, the immediacy and warmth of the illustrator-painter's touch can often be sensed in her studio's work, showing up in logos, packaging, and specialized elements of retail-interior design schemes such as banners and displays.

A logo used in materials for a special event sponsored by a local affiliate station of the ABC television network plays off the broadcasting corporation's well-known circular logo.
CREATIVE DIRECTOR: Maureen Smullen

Smullen Design created a line of special promotional materials and coordinated retail-interior decorative/advertising elements, like colossal banners, for the reopening of the expanded Warner Bros. Studio Store in New York. The printed materials were produced in limited editions whose success lay in their details, including intricate die-cuts and carefully considered palettes, which Smullen partly pumped up by mixing percentages of fluorescent colors with yellow and magenta process inks.

CREATIVE DIRECTOR: Maureen Smullen
DESIGNERS: Jill von Hartman, Maureen Smullen, Jennel Cruz

CHINESE THEATRE

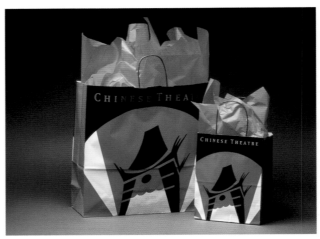

For Hollywood's landmark Mann's Chinese Theatre, with its famous, pagoda-like architectural details, Smullen designed a logo that also serves to brand the Mann chain of cinemas, which controls more than 400 screens in the U.S. The logo appears on a line of Mann-branded merchandise that the movie-theater operator sells in shops it has set up in a number of its multiplexes.

CREATIVE DIRECTOR: Maureen Smullen
DESIGNERS: Amy Hirshman, Maureen Smullen

Smullen Design created this packaging and related promotional materials for a CD-ROM game produced by Time Warner Interactive.

CREATIVE DIRECTOR/ILLUSTRATOR:
Maureen Smullen

PRINCIPAL: Denise Gonzales
Crisp
FOUNDED: 1996
NUMBER OF EMPLOYEES: 1

3129 Glendale Boulevard
Los Angeles CA 90039
TEL (213) 666-7224
FAX (213) 666-7459

SUPER STOVE!

Denise Gonzales Crisp operates the quirkily named Super Stove! studio in addition to serving as design director for Pasadena's Art Center College of Design, where she teaches typography and advises graduate students in its new-media program. She also teaches at the California Institute of the Arts. Crisp describes Super Stove! as "an independent studio dedicated to working with non-profit or break-even organizations" whose projects offer opportunities to explore "graphic design's edges and in-betweens." This helps explain her involvement with such experimental, independent publications as *Plazm* and *Émigré*, to which Crisp has contributed layouts or essays on design-related themes. Most of Super Stove!'s efforts are offered on a volunteer basis, and Crisp is an eager collaborator; she designed, with Louise Sandhaus, an interface to promote international students' digital work, and, with Anne Burdick, a Web site for an art-distribution organization. Crisp's signature style encapsulates the grid-busting, eye-challenging momentum of late postmodernism's wholly liberated page in the era that, after the influential work of David Carson, has been dubbed that of "the end of print." Typography often flexes its muscles on her rambunctious pages; at times, though, as in some of her *Offramp* layouts, they can feel cool and moody.

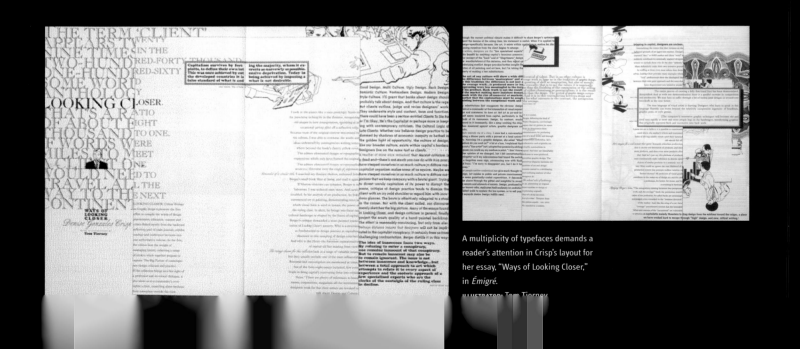

A multiplicity of typefaces demands a reader's attention in Crisp's layout for her essay, "Ways of Looking Closer," in *Émigré*.
ILLUSTRATOR: Tom Tierney

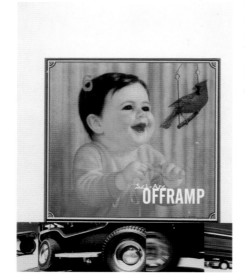

Stretched-out, column-escaping text lines and headline letterforms give a sense of moodiness and movement to this layout for *Offramp*, a magazine published by the Southern California Institute of Architecture.
COVER: Denise Gonzales Crisp, Beth Elliott, Sibylle Hagmann

Jeffrey Allsbrook & Keith Krumwiede

Los Angeles: DESTINATION URBANISM

PLUG-IN CITY IS REAL.

The support structure is a limitless network of roads rather than a super-skeleton built into the sky. There are no hover crafts or monorails, only cars, trucks and buses. The desired obsolescence is also present; disposable capsules realized in the form of buildings with a life span of forty years or less. The idea of Plug-in City exists in the form of Los Angeles.

Los Angeles is built upon mobility. It could exist without any definitive referents beyond the freeways and boulevards which service that mobility. These trajectories establish a sinuous armature which gathers urbanity even as it structures the city's dispersal. From a touristic vantage, Los Angeles is a collection of spectacular clusters of entertainment within an endless metropolitan sprawl; it appears to offer no conventionally recognizable public realm.

If we look beyond the lack of traditional forms which have come to represent urbanity and urban life, however, we can see a territory that offers other potential urbanisms.

To approach Los Angeles, it is necessary to reconceptualize urban space, abandon the search for the static realms of traditional urbanism and seek instead the city's transitional realms. As the terrain of the city has shifted over time, conventional notions of metropolitan form have characterized urban areas as following a center/periphery model; initially established as an urban core of relatively uniform intensity surrounded by radial zones of decreasing density that dissipate to an inevitable edge. This concept assigns difference primarily to urban/rural border, and as that border becomes increasingly difficult to identify,

EVERY PLACE OF ARCHITECTURE, EVERY PLACE OF HABITATION, PRESUPPOSES ONE THING: THAT THE BUILDING IS ON A WAY, AT A CROSSROADS, BY MEANS OF WHICH IT IS POSSIBLE TO COME OR TO GO. NO BUILDING EXISTS WITHOUT ROADS WHICH LEAD TO IT OR AWAY FROM IT AND NONE EXISTS WITHOUT INNER WAYS, WITHOUT CORRIDORS, STAIRS, PASSAGES, DOORS.

the model has been modified to articulate the more subtle differentiation of urban/suburban. In this model, individual suburb-satellites occupy a periphery of varying density, fracturing the urban/rural edge. Current conceptions of urbanism suggest that the singular core of former models has now been supplemented with multiple centers serving the expanding field of suburbia. Implicit in these models is the supposition that significance is attributable primarily to place. What these models fail to adequately address is the primacy of circulation in the structuring of urban hierarchies.

Los Angeles is a suburban metropolis; enhanced mobility has devalued physical proximity and supplanted the inherent economy of urban density. The expansion of flexible infrastructures of transportation and communication continue to shift value away from the specific attributes of place, toward

2. Plug-in City by Archigram, for reference see: A Guide To Archigram 1961-74. St. Martin's Press, New York 1994; pp. 110-117

1. Jacques Derrida, as quoted in "The Way is the Goal," by Gert Mattenklott, Daidalos issue 47, March 1993 pp 28-35

8

9

Black type floating over a delicate background layer of misty, blue-gray type and illustration helps set an ambiguous emotional tone for Crisp's layout of a story about adolescent love and lust in *Plazm*.
COVER PHOTOGRAPHY: Christine Cody

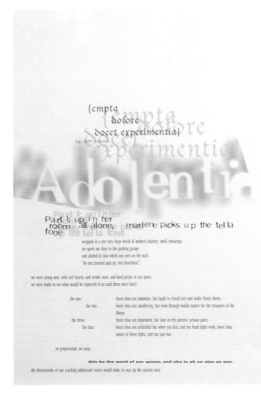

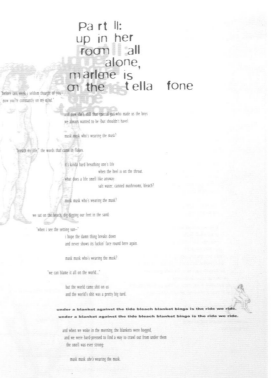

The text path is not always easy to follow—and that may be the graphic design point to ponder—in Crisp's layouts for one of her essays in *Émigré*.

Crisp's contribution to a multi-designer project sponsored by Champion International Corp. and published in *Plazm* explored the lace-like visual textures of embellished, calligraphic letterforms.

Crisp's self-published *Graphesis* contains a myriad of clever musings, in texts and images, on design, creative thinking, and the meaning of life. The large-format book highlights Crisp's work in black and white.

PRINCIPALS: Deborah Sussman,
Paul Prejza
FOUNDED: Current firm incorporated
in 1980; evolved out of the design
studio opened by Sussman in 1968.
NUMBER OF EMPLOYEES: 35

8520 Warner Drive
Culver City CA 90232
TEL (310) 836-3939
FAX (310) 836-3980

SUSSMAN/PREJZA
& COMPANY, INC.

Deborah Sussman and Paul Prejza, and their multidisciplinary team of experts—including graphic designers, architects, sign designers, interior designers, colorists, exhibit designers, and media specialists—are renowned for their expertise in the field of signage systems and environmental graphics. Sussman, one of the longtime deans of Los Angeles-based design, began her career in the offices of Charles and Ray Eames, where she worked for many years. In 1968, she opened a studio of her own in Santa Monica and launched Sussman/Prejza when her husband Paul Prejza, with his architecture and urban-planning background, joined her professionally in 1980. The firm soon became famous for its imaginative and, by all accounts, remarkably cost-effective environmental graphics for the 1984 Summer Olympics in Los Angeles. For this wide-ranging identity system, Sussman/Prejza used coordinated, vibrant color and symbols in the banners, signs, and other elements of what its creators officially dubbed "The Look" of the international event. Sussman/Prejza developed a comprehensive identity-and-signage scheme for Walt Disney World that became a template for the site's future development. The studio also worked with a myriad of public-sector representatives on a much-needed vehicular directional system in Philadelphia to guide both visitors and local residents to attractions and other destinations in the historic city. While some detractors lament the "malling" of the built environment that this kind of design approach may seem to impose or imply, Sussman/Prejza's admirers around the world applaud its thoughtful, culture-sensitive strategies for intelligently using design in everything from street signs to bus shelters to give a visible, tangible sense of unity and order to chaotic urban sprawl.

Sussman/Prejza collaborated with Barton Myers Associates, architects of the New Jersey Performing Arts Center, to create a comprehensive graphics system reflective of both the complex's many programs, but also of Newark's and the region's multi-ethnic, multicultural audiences.

Beautifully simple, the firm's logo for the City of Santa Monica refers to the sun, sea, and mountains that are the area's visible natural points of reference. Sussman/Prejza's colorful identity-and-signage systems like this one help to visually organize and unify the chaos of urban sprawl.

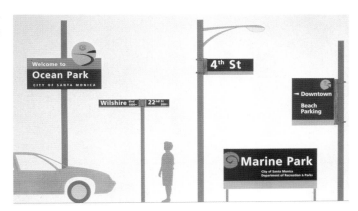

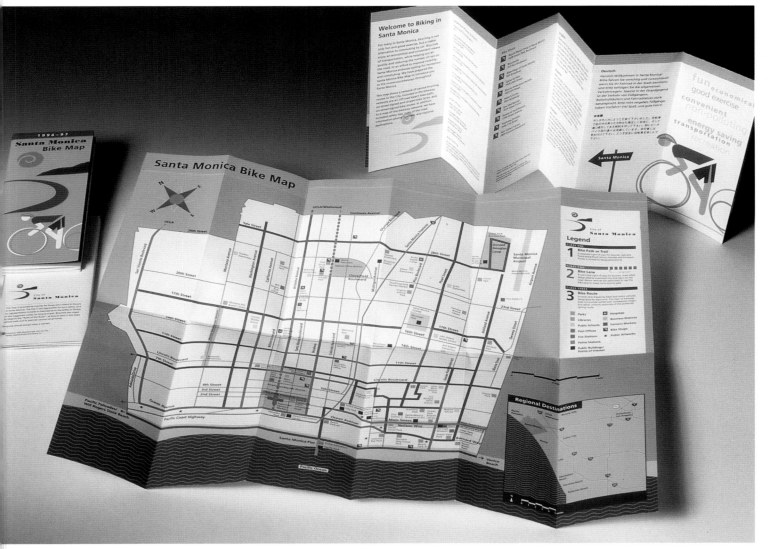

For promotional materials for a group of four new skyscrapers that are being developed at Times Square in New York, Sussman/Prejza used a monochromatic palette. The design studio also employed a main graphic motif directly inspired by the geographic footprint of the street intersection nicknamed The Crossroads of the World, where the buildings will be located.

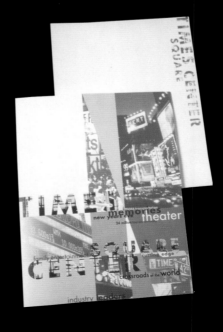

An identity system for a company
called Knowledge Exchange exploits
the visual energy of an abstracted
letter *E* in the Santa Monica-based
firm's Sussman/Prejza-designed logo.

PRINCIPAL: Alexei Tylevich
FOUNDED: 1996
NUMBER OF EMPLOYEES: 1

21 Union Jack Street, No. 3
Marina del Rey CA 90026
TEL (310) 301-0681

ALEXEI TYLEVICH

Make it fast, colorful, and attention-grabbing—those are the criteria for motion graphics in everything from hamburger and car commercials to TV news promotions and even some public-service announcements. Effortlessly fluent in the digital era's quick-cutting visual language, Alexei Tylevich instinctively serves those demands in his image-laden sequences for such clients as Sega, DKNY, and Nike. Born in Minsk, Belarus, Tylevich studied painting before immigrating to the U.S. in 1989 at age seventeen. He earned his BFA degree at the Minneapolis College of Art and Design, where he worked with designer P. Scott Makela. Tylevich is best known for his art direction for Channel One, the advertising-supported, Los Angeles-based daily news program that reaches classrooms all across America. Everything comes together in its semiotician's feast of European-style information symbols, abstract patterns, jumbled type, medical illustrations, and headline-encapsulating emblems. Among them: a map of the U.S., with Philadelphia highlighted and a title, all within a direction-indicating arrow, for news about 1997's Million-Woman March. "Colors bleed like crazy, and serif typography is impossible," Tylevich says of this work, which is downloaded from satellite feeds onto videotape for classroom viewing. As *I.D.* magazine has noted, because Channel One constantly reinvents its look, the Tylevich-dominated service "is arguably more influential than MTV [in] shaping teenagers' impressions and expectations of design."

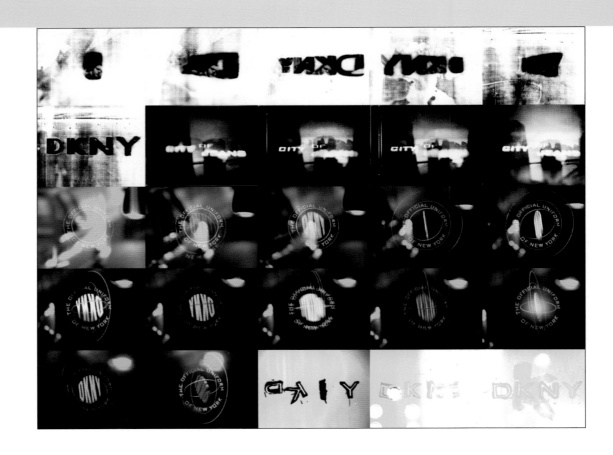

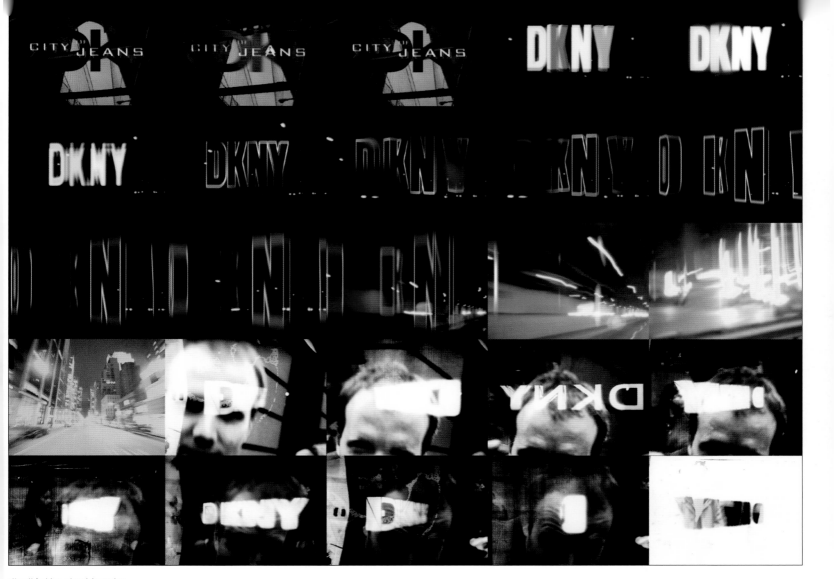

Like all fashion advertising today,
these visually rhythmic sequences
that Alexei Tylevich created for a video
produced by fashion designer Donna
Karan's in-house promotional depart-
ment for her DKNY line emphasize
image and mood as much as, if not
more than, their clothes-merchandise
subject. Tylevich lets the label's all-caps
logo become the graphic-design star;
it is, after all, the element that viewers
will most likely remember long after
the video has ended.

DESIGNERS/ANIMATION: Alexei Tylevich,
Ben Conrad

Just as sound, text, and image can combine to create a mood, such a general tone or ambiance can convey a sense of identity, as it does in Tylevich's "Revolution Radio" TV commercial for REV 105, with its message of inevitable, essential hipness.

DESIGNER/ANIMATION: Alexei Tylevich

Shimmering like liquid light, typography dances and swims in this video phantasmagoria called "The Bearded Lady," a television commercial for Sega of America that Tylevich designed and animated for the advertising agency Goodby, Silverstein & Partners.

ART DIRECTOR: Todd Grant
DIRECTOR: Kinka Usher
WRITER: Bo Coyner

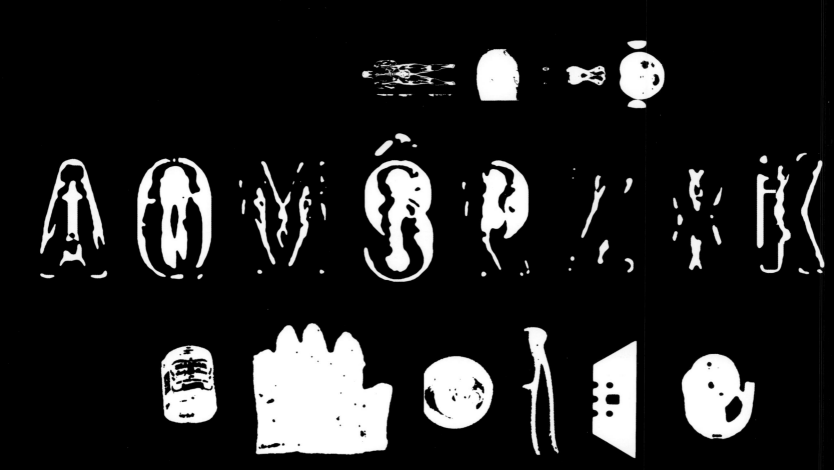

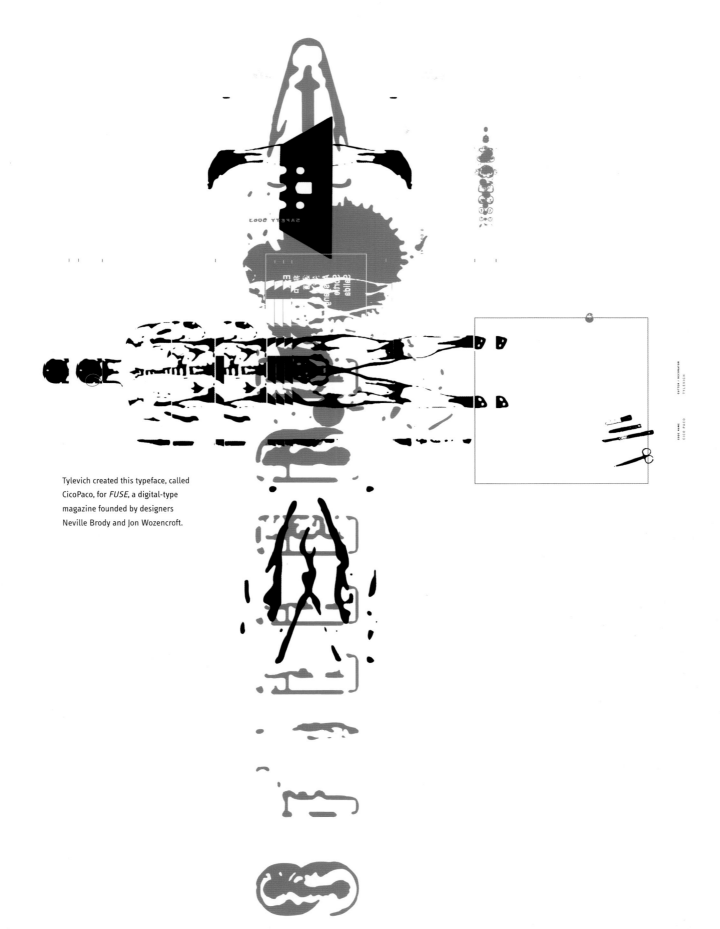

Tylevich created this typeface, called CicoPaco, for *FUSE*, a digital-type magazine founded by designers Neville Brody and Jon Wozencroft.

PRINCIPALS: MaeLin Levine
Amy Jo Levine
FOUNDED: 1987
NUMBER OF EMPLOYEES: 6

343 4th Avenue, No. 201
San Diego CA 92101
TEL (619) 233-9633
FAX (619) 233-9637

VISUAL ASYLUM

A visitor to Visual Asylum's offices immediately knows that here, with a chuckle and a wink, an exuberant design sensibility is bursting out all over. Sisters MaeLin and Amy Jo Levine, who jokingly remind clients that they come from Leadville, Colorado, a mining center and hometown of the legendary Unsinkable Molly Brown, studied at the University of Denver and at the Kansas City Art Institute, respectively. MaeLin opened the studio in 1987. In identity development, interiors, signage, exhibition and product design, and packaging, their vibrant work assimilates everything from classic animated cartoons, with their irrepressible color energy, to print jobbers' iconic clip art and even the now-familiar handling of type that might be called retro-flavored, late-postmodernist modern. An effective, attention-getting whimsy and a sense of the hand-drawn or hand-crafted characterizes much of Visual Asylum's work, as in its corporate-identity scheme and accompanying house-for-sale signs for Los Albanicos, a real-estate project, or in its bright and simple packaging for waffle mixes and granola. For all their firm's many awards, MaeLin notes that she and Amy Jo are especially proud of their work with "at-risk high-school art students through our local AIGA chapter's program that gives them an opportunity to work with design, illustration, and photography professionals."

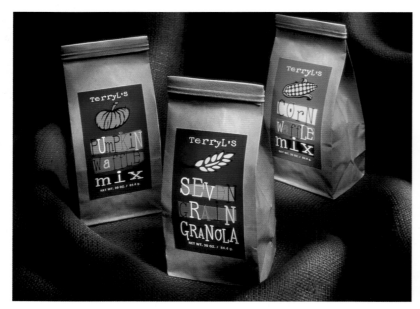

Iconic clip-art forms and a cartoonish look give this stationery and package designs for Café 222 a delightful, retro air.

ART DIRECTOR: Joel Sotelo
CREATIVE DIRECTORS: MaeLin Levine, Amy Jo Levine
PHOTOGRAPHY: Jonathan Woodward

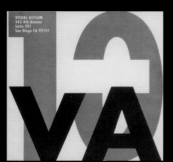

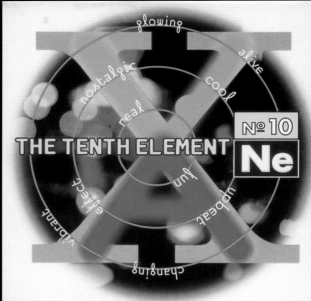

Visual Asylum's house look can take a slight techno turn, as in this tenth-anniversary self-promotional piece for the studio.

The studio's coloring book self-promotional piece is goofy, unusual—and pretty much irresistible.

ART DIRECTORS: MaeLin Levine, Amy Jo Levine

ILLUSTRATOR: Charles Glaubitz

The Levine sisters used no-holds-barred, wood-stained color in a promotional gift box for their design firm.
PHOTOGRAPHY: Jonathan Woodward

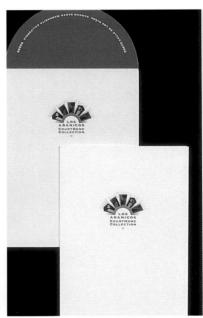

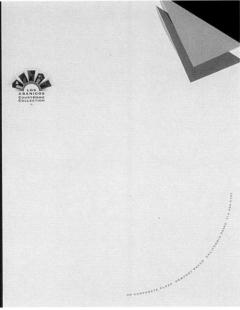

Stationery and signage for a real-estate company break with the rectilinear, serious corporate-identity norm and exude a sense of the hand-drawn.
PHOTOGRAPHY: Jeffrey Aron

Visual Asylum used a pop-up, a staple of children's books, for this promotional holiday card for a printing company.
ART DIRECTOR/ILLUSTRATOR: Paul Drohan
CREATIVE DIRECTORS: MaeLin Levine, Amy Jo Levine

Stationery for Laser Pacific.

Stationery for photographer Jonathan Woodward.

"And they were happy in their Visual Asylum": The Levine sisters' multi-fold, self-promotional piece on textured paper uses only black and green inks in a type-happy ode to the joys of graphic design.

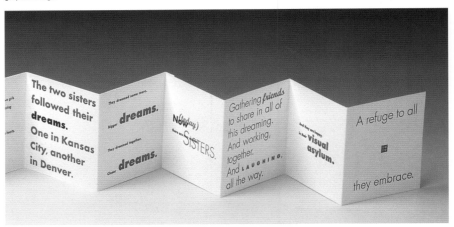

The exuberant design for which Visual Asylum is known, with its explosive color and unbridled whimsy, begins at home at the firm's brightly painted offices.

ART DIRECTORS: MaeLin Levine, Amy Jo Levine

PHOTOGRAPHY: Carol Peerce

The Levines' transformation, for Laser Pacific, of typically lackluster corporate offices in an architectural box echoes the high-charged character of their own firm's unconventional digs.

FABRICATION: Fabrication Arts

PHOTOGRAPHY: Jonathan Woodward

A direct-mail, cardboard piece for Loyola Marymount University unfolds like a fan or like a designer's brad-bound stack of color swatches.

ART DIRECTOR: Amy Jo Levine

CREATIVE DIRECTOR: MaeLin Levine

ILLUSTRATOR: David Diaz

PRINCIPAL: Petrula Vrontikis
FOUNDED: 1989
NUMBER OF EMPLOYEES: 4

2021 Pontius Avenue
Los Angeles CA 90025
TEL (310) 478-4775
FAX (310) 478-4685

VRONTIKIS DESIGN OFFICE

"Listen. Think. Design." So declares the motto on Petrula Vrontikis's stationery. Never shouting, but high on dazzle, much of her work is animated by the dotted lines, arrows, spirals, hairlines, and sprinklings of varied sizes and kinds of type that routinely pepper her designs. This award-winning educator, who teaches at Pasadena's Art Center College of Design, has commented on the importance of helping clients "understand what graphic design can do for them to get the maximum impact for their money." Thus, it would appear that part of Vrontikis's approach, even as she strives to meet clients' marketing communications goals through design, is to enable them to make an impression with whatever she creates for them, from catalogs and brochures to posters, press kits, and annual reports. Vrontikis's work follows no pre-conceived formulas. It also vividly reflects the tremendous power—and influence—of today's multifaceted computer programs in the creation of graphic design. Vrontikis can deftly apply the tricks of a computer-driven trade soberly, where appropriate, as in her booklet for the University of Southern California, or with a more festive explosion of color, as in her promotional materials for E! Entertainment Television and Time Warner Audio Entertainment.

A vibrant eclecticism, varied textures and appropriately bold, audacious color characterize the firm's designs for E! Entertainment Television's promotional items.

Vrontikis opted for a painterly, calligraphic touch in her logo and poster for Monsoon Café, a Tokyo restaurant operated by Global Dining, an international corporation.

The designer's penchant for a variegated type treatment finds a more subdued but fitting expression in a brochure for a management program offered by the University of Southern California.

PHOTOGRAPHY: Paul Ottengheime

Irritating and arbitrary, or clever and compelling? Vrontikis's jumble of type weights and sizes in this booklet for Potlatch Corp., the paper manufacturer, affects the tone and impact of the text even as it delivers the words and message that comprise it.

PHOTOGRAPHY: Tim Jones, Everard Williams, Paul Ottengheime, *Abrams/Lacagnia*

Vrontikis's promotional materials for Time Warner Audio Entertainment employ a range of type- and image-manipulation techniques.

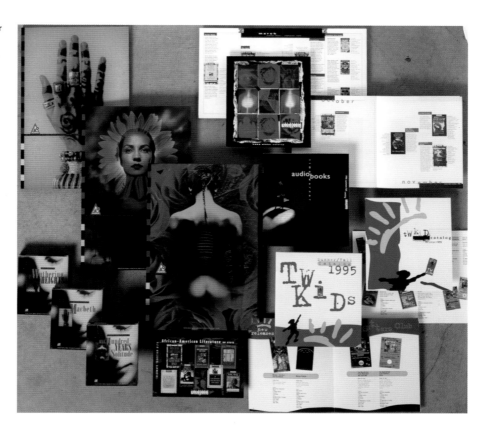

Delicate color values, a limited color palette, and no restriction to a fixed grid give Vrontikis's layouts for a Bulfinch Press book of photographs of children a poetic-playful tone.

Deep earth tones, a generic, sans-serif display type, and a legibility-challenging logo give this stationery for a new-media company a rugged character.

Vrontikis Design Office's stationery features a muted color palette and bears the motto "Listen. Think. Design." on the back side of its letterhead.

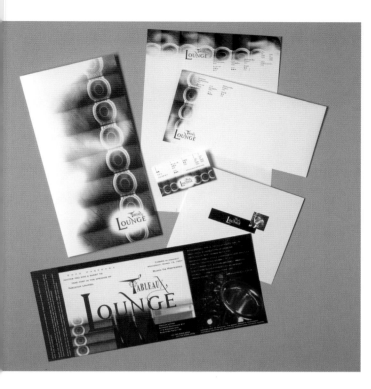

Stationery for a cigar, wine, and jazz club in trend-loving Tokyo, with dramatically elongated serifs in the logo, sets a slightly gothic-romantic mood for the nightspot.

An abstracted letter *M* in the logo for MAMA Records appears as a die-cut in its letterhead.

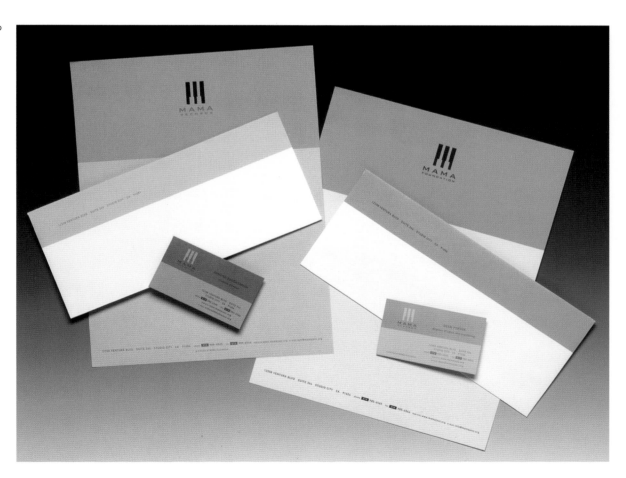

PRINCIPAL: Michael
Worthington
FOUNDED: 1997
NUMBER OF EMPLOYEES: 2

3207 Glendale Boulevard
Los Angeles CA 90039
TEL (213) 661-2349
FAX (213) 666-1245

WORTHINGTON DESIGN

As a practicing designer and a full-time member of the faculty of the California Institute of the Arts, where he earned his master of fine arts degree in 1995, Michael Worthington is well-placed to be well-informed about both current trends in the region's graphic-design world and about up-and-coming talents in the field. "Here, there's a desire to make work that is visually stunning, with a balance between intellect and style," he observes. A self-styled "technophile and typophile," the British-born Worthington has used the computer to create richly expressive, type-as-art, digital-abstract landscapes in which letterforms that have been given a workout are sprinkled, splashed, scrunched-up, or stretched across a screen or page. Worthington's work shows that he has thoroughly assimilated the dominant nineties style in which computer-aided type manipulation and an intentional edginess are de rigueur, but he brings to the exercise a strong understanding of the power of well-balanced compositions, still full of vital, spontaneous spirit, to make a strong and lasting impact. Many of his new-media designs benefit from this sensitivity and expertise, such as his type experiments for his own Web site, and those that he created for the Getty Institute's *Digital Experience* project. Worthington has applied this type-savvy touch to exhibition catalogs and promotional booklets, too.

Densely packed, separated by thickets of hairline rules of varying widths, or sprinkled on a page against a spacious white background, headlines, text blocks, and silhouetted photo images do a sprightly dance together in these layouts for a promotional booklet for L.A. Eyeworks, the high-fashion eyewear retailer.

ART DIRECTOR/CREATIVE DIRECTOR:
Michael Worthington
DESIGN ASSISTANT: Tracy Hopcus
TYPEFACE DESIGN: Capricorn,
by Jens Gelhaar
PHOTOGRAPHY: Various photographers,
including portraits by Greg Gorman

WHEN IT IS DONE
THIS SITE WILL BE
ABOUT
typography
AND

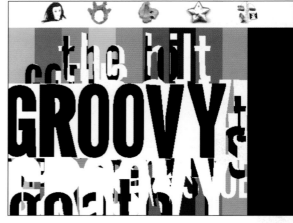

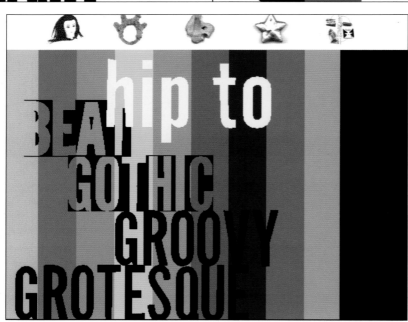

hip to
BEAT
GOTHIC
GROOVY
GROTESQUE

Worthington works out and
presents many of his typographic
and compositional ideas on his own
Web site's pages (http://.home.
earthlink. net/~maxfish/); later
they may appear in some form
in or they may inspire actual
design assignments.

ART DIRECTOR/CREATIVE DIRECTOR:
Michael Worthington

TYPEFACE DESIGN: Michael Worthington

Typography plays a major role in Worthington's design of a catalog for an exhibition called *Things That Quicken the Heart* at the California Museum of Photography. Worthington also designed the show's installation and accompanying video titles.

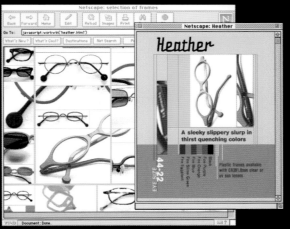

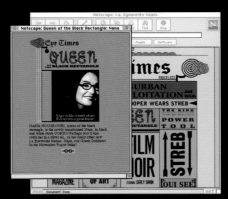

Worthington captures the sassiness and verve of L.A. Eyeworks' popular print-advertising campaign and corporate image in his designs for the company's Web site in which, typically, typography is the hard-working star.

ART DIRECTOR/CREATIVE DIRECTOR:
Michael Worthington
DESIGN ASSISTANT: Tracy Hopcus
TYPEFACE DESIGN: Capricorn,
by Jens Gelhaar
PHOTOGRAPHY: Various photographers,
including portraits by Greg Gorman
ILLUSTRATOR: Louise Bonnet

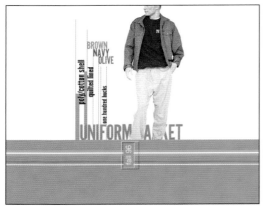

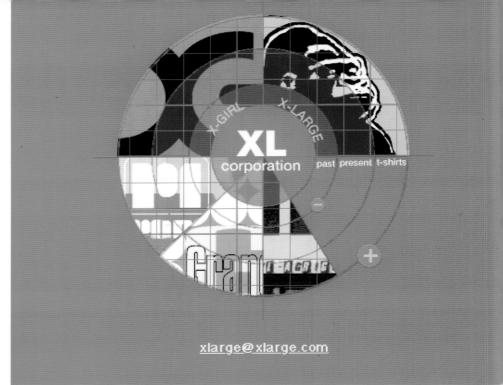

For a fashion company with an unconventional attitude that sells its products through its Web site, Worthington created screen-page layouts with a similarly distinctive flavor. Here again, the assignment offered the designer opportunities to apply the findings of his ongoing typographic experiments.

DESIGNERS: Michael Worthington, Tracy Hopcus

PHOTOGRAPHY: Various photographers, including Sophia Coppola, Michael Worthington

ORIGINAL T-SHIRT ARTWORK: X-Large Corp.

Worthington's intriguing animated typographic sequence for the Getty Institute's *Digital Experience* is part of a larger collaborative project with Post Tool and Michael Maltzan Architecture for the well-known art-and-culture center.

ART DIRECTOR/CREATIVE DIRECTOR:
Michael Worthington

About the Author

EDWARD M. GOMEZ's background is in philosophy and design; he is a former cultural correspondent for *Time* in New York, Paris, and Tokyo, and senior editor of *Metropolitan Home*. A contributing editor of *Art & Antiques* magazine, Gomez has also written on art and design for the *New York Times, Metropolis, ARTnews*, the *Japan Times, Condé Nast Traveler, Eye* and *Raw Vision*. He is one of the contributing authors of *Le dictionnaire de la civilisation japonaise* (Hazan Éditions).

Gomez, who studied at Duke University, Oxford University, and Pratt Institute, is a visiting professor of design history and aesthetics at Pratt Institute in New York. He has won Fulbright and Asian Cultural Council fellowships to Japan for his work on the history of Japanese modern art, and Switzerland's Pro Helvetia award for his writing on the outsider artist Adolf Wölfli. Gomez has lived and worked in England, France, Italy, Jamaica, and Japan, and is now based in New York.